太极拳对练
Taijiquan Pair Sparring

YouTube 學習太極拳對練 　　優酷學習太極拳對練

目　錄
Table of Contents

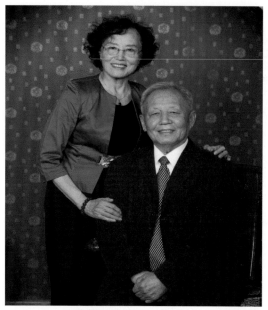

作者夫妻金婚 50 年 (2017 年)

作者八卦拳照

作者太極拳照

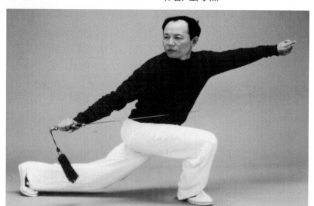

作者武當劍照

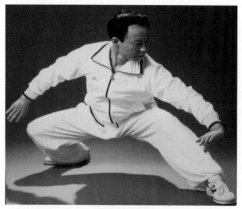

作者形意拳照

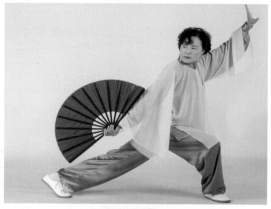

作者太極扇照

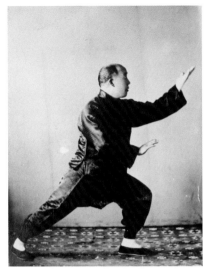

作者的祖父李玉琳太極拳照

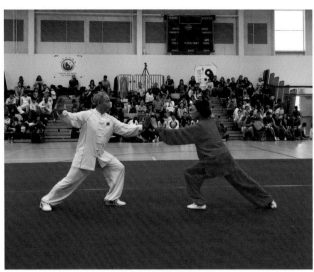

作者夫妻表演太極拳對練

作者叔父李天驥傳藝八卦掌

作者父親李天池太極劍照

作者女兒李暉長拳照

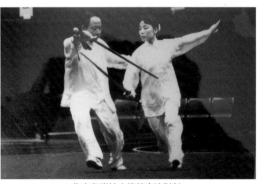

作者與堂妹李德芳表演對劍

與中國武術協會主席張躍庭（中）一行同訪少林寺

在蔡龍雲老師領導下執行裁判工作

作者夫婦拜望太極拳前輩孫劍雲老師

1977年國家體委武術調研組合影（前：溫敬明、張山、李天驥。中：王菊蓉、張文廣、王潔。後：習雲太、李德印、何福生）

與武術名家李文貞老師親切交談

與太極拳名師陳小旺交流推手

中國人民大學李德印太極拳教學展演會

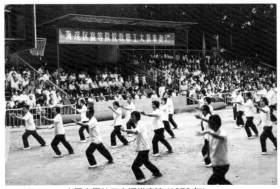

人民大學教工太極拳表演 (1979 年)

中國人民大學青年學子的太極拳體育課

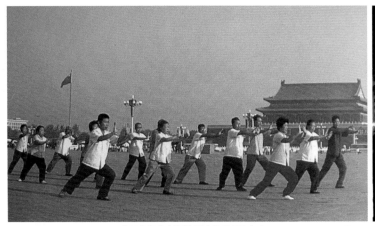

天安門廣場的太極拳晨練者 (1978 年)

北京飯店附近的太極拳比賽

一、太極拳對練介紹

太極拳對練是一套雙人對打形式的楊式太極拳傳統套路，最初名稱叫"太極拳散手"。1943年，上海楊式太極拳傳人陳炎林先生在《太極拳、刀、劍、桿、散手合編》書中最早公布於世，1979年，著名武術家、雲南省武術隊教練沙國政先生，對太極拳散手進行了整理改編，改名"太極拳對練"單冊出版。我們今天介紹的就是依據以上兩位老師的整編版本。

太極拳對練的最大特點，就是把太極拳動作的攻防含意，通過兩人對打的形式直觀地表現出來。幫助太極拳練習者更好地理解，在單練中難以體會的太極拳攻防招法和攻防特點。

對練套路並不是兩個人的格鬥比賽，而是事先安排的模擬實戰的套路練習。這套對練充分表現了太極拳以靜製動，以柔克剛的攻防技法，展現了太極拳隨屈就伸，不丟不頂的運動特點。通過練習不僅提高練習者太極拳的運動要領和攻防技巧，還可以提高練習者相互協調配合的能力。

這套對練構思巧妙，攻防合理，內容豐富，特點突出。演練起來，勢勢相承，環環相扣，剛柔相濟，意趣盎然。把太極拳的運動特點、文化內含和健身性、攻防性、趣味性表現得十分充分，是一項值得發揚的優秀傳統套路。

1. Introduction to Taijiquan Pair Sparring

Taijiquan pair sparring is a traditional Yang–style Taijiquan routine in the form of two–person sparring. Its original name was " Taijiquan free combat ". In 1943, it was first published in Shanghai Tai Chi master Chen, Yanlin's book <<Compilation of Taijiquan, Broadsword, Sword, Cudgel, Free Combat >>, which is a representative comprehensive work of Yang style Tai Chi. In 1979, Mr. Sha, Guozheng, a well–known martial artist and coach of the Yunnan Provincial Wushu Team, collated and adapted Taijiquan Sanshou, which was renamed " Taijiquan Pair Sparring " and published as a Single–volume publication. What we are introducing today is based on the compiled version of the above two masters.

The most important characteristic of Taijiquan pair sparring is to manifest directly the offensive and defensive awareness of Taijiquan movements through the form of two–person sparring. It helps Taijiquan practitioners better understand the techniques and characteristics of offensive and defensive awareness of Taijiquan that might be difficult to understand in one's single practice.

A pair sparring routine is not a two–person fighting competition, instead a pre–arranged exercise that simulates real combat. This routine fully manifests Taijiquan's offensive and defensive techniques of stillness controlling movement and softness overcoming rigidity and demonstrates characteristic of Taijiquan's motion which I stretch while opponent flexes, neither separate nor making forcible contact. Through practice, it improves not only the key points of movements and offensive and defensive techniques of the practitioners but also the ability of the practitioners to coordinate and cooperate.

This pair sparring routine is ingeniously conceived, reasonable offensive and defensive arrangement, rich in content, outstanding in features. During practicing, every movement is well connected to and interlocked with each other, changes between rigidity and softness in harmony, and full of interest. The motion– characteristics, cultural connotation, health–preserving, awareness of offensiveness and defensiveness, and the fun of Taijiquan is fully demonstrated, which is an excellent traditional routine worth promoting.

二、太極拳對練要求

任何武術對練套路的優秀標準都要達到以下四條，太極拳對練也不例外。

（一）攻防合理。武術對練是直觀地表現武術的攻防招法，這是武術與體操、舞蹈的本質區別。如果說在武術單練套路中吸取一定的体操、舞蹈元素是必要的，在對練中脫離武術攻防的體操、舞蹈就是不倫不類。既使是象形拳術的对练，也要形醉意不醉，不能背棄攻防招法，賣弄猴形、醉態。武術對練不能做成雙人操、雙人舞。

（二）特點突出。武術對練不僅要求攻防合理，更要表現出本拳種的攻防特點。太極拳對練要突出以柔克剛，隨屈就伸的特點；形意拳要表現直打猛攻，近戰快戰的特點；翻子拳要求"雙拳密如雨，脆快一掛鞭"；戳腳彈腿要求"手是兩扇門，全憑腿打人"。總之，武術各門各派、南拳北腿，各有奇招特長，展現自己的特色才是優秀對練。所以武術拳師總是強調"先單練，後對練"，"先徒手，後器械"，練好本門派的基本功，再開始對練。

（三）配合嚴密。雙人對練是按事先設計好的固定動作演練，需要兩人密切配合。不僅攻防合理，在時間上距離上還要做到嚴絲合縫兒，勿過勿不及。不能出現誤打誤傷，攻防落空，有攻無防，先防後攻等失誤現象。同一對練套路，不同的人演練，在速度、距離的掌握上都會有所不同。演練者不僅要把握好自己，還要熟悉對方，適應對方，尊重對方，相互配合。使對方舒服地出色地完成對練。

（四）形神合一。對練還要求動作逼真，全神貫註，形神合一。對練中的武術精氣神絲毫不弱於單練。切不可埋頭招法，謹小慎微，畏縮不前，忽視氣勢和神態，不講究身法、步法、勁力、節奏，練成一副有形無意，有外無內的空架子。

2. Requirements of Taijiquan Pair Sparring

The standards of any excellent martial arts pair practice routine must meet the following four requirements, so is Taijiquan Pair Sparring.

1.Reasonable of offense and defense. Martial arts pair sparring moves are the direct expression of offensive and defensive techniques of martial arts. This is the essential difference between martial arts and gymnastics, dance. If one takes certain gymnastics skills and dance appearances in martial arts single practicing routine, are necessary and reasonable. But gymnastic and dancing moves that break away from the offensive and defensive awareness of martial arts in the pair sparring training are nondescript. Even if pair sparring practices in imitation boxing, like drunken boxing and monkey style boxing, you should be drunk in form, but not in mind, you are supposed not to abandon offensive and defensive techniques and just show off the monkey form and drunken state. Martial arts' pair sparring exercises cannot be made into the pair–gymnastics and the pair– dancing.

(2) Outstanding characteristics: It is required not only the rationality of offensiveness and defensiveness but also more important to demonstrate the offensive and defensive characteristics of this kind of boxing. The characteristics of softness overcoming rigidity and I stretching while opponent flexing should be highlighted in Taijiquan pair sparring practice. Xingyiquan should demonstrate the characteristics of straight and fierce attack, close contact, and fast combat; Fanziquan should be " two punches hitting like rain, quick like a string firecracker". Snap kick manifests "hands defense oneself like two doors, and relying entirely on one' s leg to beat the opponent." In short, no matter Nanquan or Baitui, each school of martial arts has its unique techniques and specialties. An excellent pair sparring is to manifest characteristics of its school. Therefore, it is always emphasized by martial arts' masters about the sequence in our learning process as "single training first, then pair training", "bare hands first, then Wushu weapons", and practice the basic skills of the school before beginning with pair sparring training.

(3) Close cooperation: Pair sparring practice is performed according to predesigned fixed movements and requires close cooperation between two practitioners. Besides the rationality of offensiveness and defensiveness, the time and distance must be tightly matched without going too much or less. Mistakes should be avoided such as missed hits and injuries, ineffective offense and defense, attack without defense, first–defense and then–offensive, etc. The same sparring routine performed by a different person will differ in terms of speed and distance. Hence, it is important for the practitioners not only to be able to control themselves but also become familiar with each other, adapt to each other, respect each other and cooperate to enable the partner to feel comfortable to accomplish excellently in sparring exercise

(4) Integration of form and spirit as one: The pair sparring practice also needs to act like real with intense concentration as well as the integration of form and spirit as one. The requirement of willpower, energy, and spirit of martial arts in sparring practice is no less than in single practice. It is recommended not to bury your head in the techniques, be too cautious to step forward, not to neglect the usage of imposing manner and appearance, or not to fail to pay attention to your body techniques, foot techniques, application of force, and rhythm, otherwise, you practice a form but no awareness, an external but no internal, like an empty frame.

三、太極拳對練動作名稱

Movements' Names of Taijiquan Pair Sparring

预备势 Ready Position

第一段 Section 1

（一）甲、乙起勢　　　A,B-Opening form

（二）甲、乙攬紮衣　　A,B-Fasten coat

（三）甲、乙開合手　　A,B-opening and closing hands

（四）甲、乙單鞭　　　A,B-Single Whip

（五）甲上步沖捶　　　A-step forward and punch fist

（六）乙退步提手　　　B-step backward and raise hands

（七）甲搬手沖捶　　　A-block and punch fist

（八）乙摟手沖捶　　　B-hand block and punch fist

（九）甲換步左靠　　　A-change steps and squeeze to the left

（十）乙右貫拳伏虎　　B-sweep right side and punch and tame the tiger

（十一）甲馬步頂肘　　A-Horse stance jab elbow

（十二）乙轉腰推肘　　B-turn waist and push elbow

（十三）甲左披身捶　　A-Fists roll over body

（十四）乙托肘右靠　　B-lift elbow and squeeze to the right

（十五）甲左貫拳伏虎　A-sweep left side and punch and tame the tiger

（十六）乙化打撇捶　B-neutralize opponent's force point and turn body and throw fist

（十七）甲提手上勢　A-raise hand and step up

（十八）乙轉身化按　B-turn body and neutralize and press

（十九）甲摺疊沖捶　A-fold and punch

（二十）乙搬手沖捶　B-deflect hand and punch fist

（二一）甲搬手橫捌　A-deflect hand and pull horrizontally

（二二）乙野馬分鬃　B-Wild Horse Parts Manne

第二段 Section 2

（二三）甲右貫拳伏虎　A-sweep right side and punch and tame the tiger

（二四）乙轉身大将　B-turn body and large deflection

（二五）甲上步左靠　A-step forward and squeeze to the left

（二六）乙繞步推按　B-circle steps and push-press

（二七）甲十字蹬腳　A-(front) cross kick

（二八）乙換步指襠捶　B-change steps and strike groin with fist

（二九）甲採手橫捌　A-grab hands and pull horrizontally

（三十）乙玉女穿梭　B-Jade Maiden Working Shuttles

（三一）甲摟手撇捶　A-brush hand and turn body and smash fist

（三二）乙白鶴亮翅　B-White Crane Flashes its Wings

（三三）甲纏臂左靠　　A-twining arm and squeeze to the left

（三四）乙繞步撇臂　　B-circle step and pouting with arm

（三五）甲翻身推按　　A-turn body and push-press

（三六）乙雙峰貫耳　　B-Strike Opponent's Ears With Both Fists

（三七）甲換步雙按　　A-change steps and press with two hands

（三八）乙化打沖捶　　B-neutralize opponent's force point and Punch fist

（三九）甲閃身推臂　　A-elude(dodge) and push arm

（四十）乙挎肘剪臂　　B-carry elbow and crosscut arm

（四一）甲弓步推肘　　A-bow stance and push elbow

（四二）乙返身撇捶　　B-turn back and smash the fist

（四三）甲轉腰化按　　A-turn waist and neutralize and press

（四四）乙化打疊肘　　B-neutralize opponent's force point and Fold elbow

（四五）甲採手橫捌　　A-grap hands and pull horrizontally

（四六）乙換步撇臂　　B-change steps and pouting arm

第三段　Section 3

（四七）甲右貫拳伏虎　A-sweep right side and punch and tame the tiger

（四八）乙轉身大捋　　B-turn body and large deflection

（四九）甲上步左靠　　A-step forward and squeeze to the left

（五十）乙弓步回擠　　B—bow stance and press back

（五一）甲換步分靠　　A—change steps and separate and squeeze

（五二）乙換步穿靠　　B—change steps and Piercing the palm and squeeze

（五三）甲摘手頂肘　　A—pick up hand and jab elbow

（五四）乙金雞獨立　　B—Golden Rooster Stands on one Leg

（五五）甲退步合按　　A—step backwards and press hands inwards

（五六）乙十字蹬腳　　B—cross kick

（五七）甲纏臂左靠　　A—twining arm and squeeze to the left

（五八）乙繞步撅臂　　B—circle step and pouting with arm

（五九）甲右分腳　　A—separate legs and kick right

（六十）乙右摟膝　　B—brush knee –left

（六一）甲左分腳　　A—separate legs and kick left

（六二）乙左摟膝　　B—brush knee – right

（六三）甲採手右靠　　A—pull hand and squeeze to the right

（六四）乙採手回靠　　B—pull hand and squeeze against

（六五）甲換步左掤　　A—change steps and ward off left

（六六）乙退步右攔　　B—step backward and block right

（六七）甲上步右掤　　A—step forward and ward off right

（六八）乙退步左攔　　B—step backward and block left

（六九）甲披身捌打　　A—fists roll over body and ward off and hit

（七十）乙白蛇吐信　　B—White Snake Spits Tongue

第四段 Section 4

（七一）甲高探馬　　A—High Pat on Horse

（七二）乙分手踩腿　　B—separate hands and stamp leg

（七三）甲轉身擺蓮　　A—Turn and sweep the Lotus

（七四）乙單鞭下勢　　B—the Single whip and creeps down

（七五）甲退步栽捶　　A—step backward and punch downward

（七六）乙換步斜飛勢　　B—change steps and flying the oblique posture

（七七）甲左貫拳伏虎　　A—sweep left side and punch and tame the tiger

（七八）乙化打撇捶　　B—neutralize opponent's force point and turn body and throw fist

（七九）甲右倒撞猴　　A—step back ape fend off –right

（八十）乙右雲手　　B—Cloud Hands right

（八一）甲左倒撞猴　　A—step back ape fend off –left

（八二）乙左雲手　　A—step back ape fend off –left

（八三）甲右倒撞猴　　A—step back ape fend off–right

（八四）乙上步七星　　B—Scoop Palm and Creeps Down

（八五）甲海底針　　A—Needle at Bottom of the Sea

（八六）乙扇通背	B-fan the arm
（八七）甲手揮琵琶	A-Strum the Lute
（八八）乙彎弓射虎	B-curved bow to shoot tiger
（八九）甲虛步單鞭	A-single wipe in empty stance
（九十）乙攔掌沖捶	B-block palm and punch fist
（九一）甲穿掌鎖喉	A-thread (spiercing) palm and lock throat
（九二）乙如封似閉	B-Apparent close up
（九三）甲掤手雙按	A-ward off and press two hands
（九四）乙抱虎歸山	B-embrace the tiger and return to the mountain
（九五）甲、乙退步跨虎	A、B-turn body and swing (Lotus) kick
（九六）甲、乙轉身擺蓮腳	A、B-turn body and swing (Lotus) kick
（九七）甲、乙右彎弓射虎	A、B-curved bow to shoot tiger-righ
（九八）甲、乙左彎弓射虎	A、B-curved bow to shoot tiger-left
（九九）甲、乙進步搬攔捶	A、B-steps forwards deflect, parry and punch
（一OO）甲、乙如封似閉	A、B-Apparent close up
（一O一）甲、乙十字手	A、B-Cross Hands
（一O二）甲、乙收勢還原	A、B-closing form, return to original stance1

四、太極拳對練動作圖解
Movements and Illustrations of Taijiquan Pair Sparring

预备勢（圖1、2、3）
Ready Position (Fig.1,2,3)

圖 1

動作：甲乙相對而立，相距約1.5米（圖1）。二人互致抱拳禮（圖2）。禮畢後同時向右轉身，再向右後方退一步（圖3）。倆人假設甲面向南，乙面向北。自然站立，兩手貼於大腿外側。兩腳跟靠攏，腳尖外撇成八字。眼向前平視，呼吸自然。

Movements: A and B stand opposite each other, about 1.5 meters apart (Fig.1). The two exchanged fist holding ceremony (Fig.2). After the ceremony, turn to the right at the same time, and then take a step back to the right (Fig.3). Suppose A faces South and B faces North. Stand naturally with hands on the outside of the thighs. Both heels are closed together, and the toes are pointing outwards to form a V-form(a figure of eight in Chinese),looking straight ahead and breathe naturally.

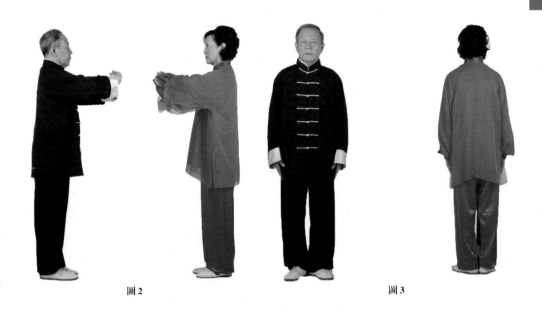

圖2　　　　　　　　　　　　　　　　　　　　圖3

　　要點： 抱拳禮是中華武術中向對方致意問候，習武重德的傳統禮儀。作法是：右手握拳，四指屈於掌心，姆指压在食指、中指第二指節；左手虎口夾緊，姆指屈曲，四指並攏伸直，輕圧在右拳拳面上。兩臂屈肘環抱，拳掌合於胸前，距身體20-30厘米，拳心向下。目視前方。身型要求：中正安舒，頂頭沈肩，含胸展背，呼吸自然。

Key points: The holding fist ceremony is a traditional etiquette in Chinese martial arts to greet each other and to practice martial arts with respect for virtue. The method is to clench the right fist with four fingers flexed on the palm, with the thumb pressing on the second knuckle of the index finger and middle finger; clamp the mouth of the left hand, flex the thumb, straighten the other four fingers together, and gently press it on the right fist surface. Bend both elbows to embrace your arms around, in front of your chest, about 20-30 cm away from your body, with the heart of your fists facing downwards, looking ahead. The requirements body shape: The shape is to be straightened, balanced, stable and at comfortable status, lift top and lower shoulders, contract the chests and extend the back, breathing naturally.

第一段 section 1

(一) 甲、乙起勢 (圖4) A,B - Opening form(Fig.4)

圖4

動作:甲、乙同時右腳尖內扣落實，身體半面向左轉，二人斜相對（圖4）。

Movements: At the same time, A and B buckle their right toes inward, turn half of the bodies to the left, facing each other diagonally(Fig.4)

要點: 心靜體鬆，中正安舒，呼吸自然。

Key points: The heart is still and the body is loose, the center is healthy and comfortable, and the breathing is natural.

(二) 甲、乙攬扎衣 (圖5-10) A,B - Fasten coat (Fig.5-10)

動作: 1、甲、乙同時兩臂向前慢慢舉起，兩肘微屈，兩手心相對，拇指向上，高與肩平，與肩同寬（圖5）。

Movements: a. At the same time, both A and B raise their arms forwards slowly, bend elbows slightly, with their palms facing each other, and at shoulder- height and shoulder-width, thumbs facing up (Fig. 5).

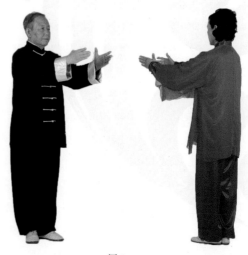

圖5

2、接上勢，沈肩落臂，屈腿下蹲。兩手緩緩下落收到腹前。同時左腳輕輕向前邁出一步，腳跟著地（圖6）。

b. Following the above moment, sink the shoulders and arms, bend the legs to squat down, move both of the hands slowly down to the front of the abdomen, meanwhile stepping the left feet gently forwards with the toes up(Fig.6).

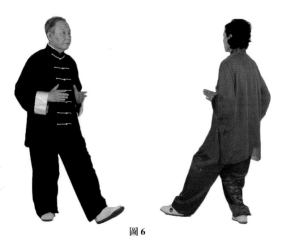

圖 6

3、重心前移，左腳踏實，右腳向前跟步，停於左腳側後方，前腳掌著地。同時兩手上提，經胸前向前伸出，兩臂微屈，掌心相對，與肩同高同寬。眼看兩掌之間（圖7）。

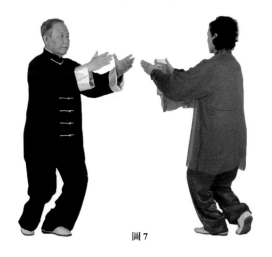

圖 7

c. Shift the body weights forwards, step firmly with the left feet on the ground, the right feet follow forwards and stop at the side of the left foot rear, and resting the soles of the forefoot on the ground. At the same time, raise both of the hands, extend forward and pass the chest, slightly bend both arms, the palms facing each other, at shoulder- height and shoulder- width, looking through between the palms (Fig 7).

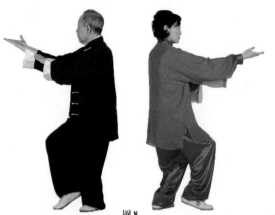

圖 8

4、接上勢，二人同時以左腳跟和右腳掌為軸，向右碾腳轉體。兩臂隨身體轉動，右臂外旋，向前（甲向西，乙向東）平舉，掌心朝上；左臂內旋，掌心朝下，四指尖附在右前臂內側。眼隨視右掌（圖8）。

d. Following the above moment, at the same time, both A and B grind the feet and turn to the right with the left heels and the soles of the forefoot as the axis; with the turn of the body, rotate the right arms outwards, forwards levelly (A towards the west, B towards the east), palms facing up; rotate the left arms inwards, the palms facing down, and attach the four fingertips to the inside of the right forearm, eyes following the right palms (Fig. 8).

5、上勢不停，繼續向右轉腰揮臂。右掌向右劃弧，再隨腰向左回轉，屈收至右肩前，掌心轉朝前；左掌附於右前臂內側，隨之轉動劃弧，轉至體前時，掌心也轉向前。同時右腳向前上步，腳跟著地，眼看前方（圖9）。

e. Without stopping, continue turning to the right and swinging the arms along with; draw the right palms in an arc to the right, then rotate them a little bit back to the left with the waists, bend them in front of the right shoulders, the palms facing forwards; the left palms attach to the inside of the right forearms and follow them in an arc, palm facing upward; when the palms are rotated to the front, step the right feet forwards, resting the heels on the ground, and looking straight ahead(Fig.9).

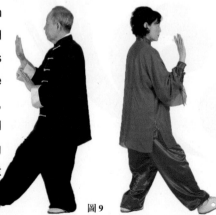

圖 9

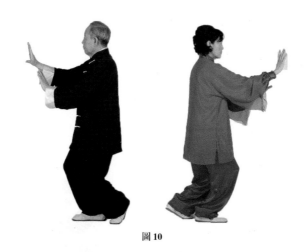

圖10

6、重心前移，左腳跟步收至右腳側後方，前腳掌著地。同時兩掌向前推出，右掌同肩高，左掌同胸高，兩掌與頭同寬。眼看前方，甲朝向西，乙朝向東（圖10）。

f. Shift the body weights forwards, left feet to follow forwards and close at the side of right feet rear, resting the soles of forefeet on the ground; at the same time, push both palms forwards, right palms are at shoulder- height, left palms are at chest-height, and the two palms are at head-width, looking straight forwards, A is facing to the west and B is facing to the east (Figure 10).

要點：碾腳轉身時，身體要平穩，動作要連貫。兩掌前推時，五指自然伸直，掌心內含，虎口成弧形。

Key points: When grinding and rotating the feet and turning around, the bodies must be steady and movements must be continuous. When pushing both palms forwards, the five fingers are to straighten naturally, contract the middle of the palms,and the tiger's mouth is to form an arc.

(三) 甲、乙開合手 (圖 11、12)
A,B – opening and closing hands (Fig.11,12)

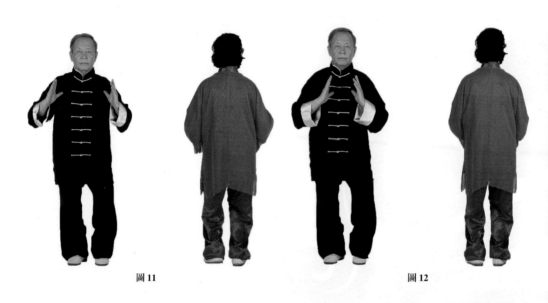

圖 11　　　　　　　　　　　　　　　圖 12

動作: 1、甲、乙左腳跟內轉，右腳尖內扣，向左碾腳轉體，身體恢復成南北朝向。同時兩手收至胸前，向左右分開，與肩同寬，掌心相對，指尖朝上。眼看前方（圖11）。

Movements: a.A and B rotate the left heels inward, buckle the right toes inward, grind and rotate the feet to the left, and turn the bodies back to the south-north; at the same time, separate both palms left and right and move them to the front of the chest, at shoulder-width apart, palms facing each other, and fingertips facing upwards, looking straight ahead(Fig. 11).

2、體重右移，左腳跟提起。兩手向中間合抱，與頭同寬，掌心相對，指尖朝上。眼看前方（圖12）。

b.Shift the body weight to the right and lift the left heels. press two palms toward the center to at head-width, palms facing each other, fingertips facing up, looking straight ahead (Fig. 12)

要點： 碾腳時重心保持平穩，體重先微向左移，再向右移。

Key points: Key points: Keep your weight steady as you grind your feet, shifting your weight slightly to the left and then to the right.

(四) 甲、乙單鞭 (圖13)　A,B - Single Whip(Fig.13)

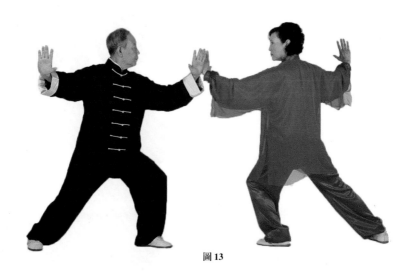

圖 13

動作： 甲、乙左腳輕輕向左橫邁一步，重心左移，左腿屈弓，成側弓步。同時兩臂內旋，兩手向左右平分撐開，與肩同高，兩掌掌心向外。頭向左轉，眼看對方，甲面向東，乙面向西。兩人左掌心斜相對，相距約10厘米（圖13）。

Movements: A and B step left feet sideways to the left gently, shift the body weights to the left, and bend the left legs to form a side bow stance; at the same time, rotate both arms outwards, and separate both palms levelly to the left and right, at shoulder- height with palms facing outwards; turn the heads to the left, looking at each other; A is facing to the east and B is facing to the west, the left palms of the two persons are facing each other diagonally, about 10 cm apart (Figure 13).

要點: 側弓步的要領是：身體側向，兩腿左右分開，一腿屈弓，另一腿自然伸直，兩腳平行或略成八字。

Key points: The essentials of a side bow stance are as follows, move the body sideways, the two legs are separated, one leg is bent, the other one is naturally straight, and the feet are parallel or slightly form a V-form (a figure of eight in Chinese).

（五）甲上步冲捶 （圖 14、15）
A - step forward and punch fist(Fig. 14,15)

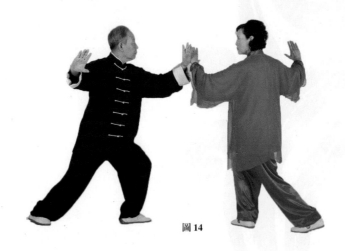

圖 14

招法: 上步右冲拳。

Tactics: Step forwards and punch the right fist

動作: 1、左腳向前活步，腳尖外撇，重心前移。左手挑開乙的左掌（圖14）

Movements: a.A makes a free moving of the left foot forwards facing outwards and shift the bodyweight forwards, and with the left palm fends off B's left palm (Fig. 14)

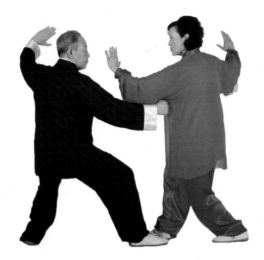

圖 15

2、右腳隨之上步，成小弓步或半馬步。同時左掌向上向右劃弧，舉於頭側上方，掌心斜向上；右掌握拳，經腰間向乙左肋沖打，拳眼朝上。目視前（東）方（圖15）。

a.Then steps the right foot forwards to form a small bow stance or a half-horse-riding stance; at the same time, draw the left palm in an arc upwards to the right and hold above the side of the head with the palm tilting upwards; clench the right fist and punches towards the left rib of B through the waist, the eye of the fist facing upward, looking at the front (the east) side (Fig. 15).

要點：把握時機和控製距離，是做好對練的關鍵。本式最後步型是弓步或小弓步，也可以半馬步或虛步。應審時度勢，以招法準確有效，勿過勿不及為準。

Key points: Getting the right timing and controlling the distance is the key to good sparring exercise. The last step of this form is a bow stance or small bow stance; alternatively, it can also be a half horse stance or an empty stance; it should be judged according to the timing and situation and the Tactics should be accurate and effective, neither too much nor too less.

(六) 乙退步提手 (圖 16)
B-step backward and raise hands(Fig.16)

招法: 退左步，活右步，提手掤擋。

Tactics: step the left foot backwards, free moving of the right foot, raise palm to ward off

動作: 乙左腳向後退步（參見图15），右腳活步前移，前腳掌著地，成右虛步。同時右掌由後向下、向前劃弧，側立掌提至體前，掌心向左，掌背掤於甲右腕外側；左掌由前向上劃弧，停於頭側上方，掌心斜向上。目視前（西）方（圖16）

Movements: B steps the left foot backwards, makes a free moving of the right foot, then steps forwards, resting the forefoot on the ground to form an empty stance; at the same time, draw the right palm in an arc downwards and forwards from the back to the front, raise the palm to the front of the body to form a side standing palm, palm facing to the left, the back of the palm at the outside of the A's right wrist in defense, draw the left palm in an arc upwards from the front to the upper side of the head, the palm tilting upwards, looking forward (the West) (Fig. 15, 16)

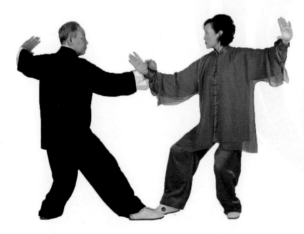

圖 16

要點： 掤手是太極拳八法之一。意在粘附、格擋對方。此處提手為上掤，不要做成上挑。

Key points: Ward-off-hand is one of the eight techniques of Taijiquan The intention is to stick to and block opponent. The raising hand here is to ward off high, do not make it into the upwards pick.

(七) 甲搬手沖捶 (圖 17、18)
A–block and punch fist(Fig.17,18)

招法： 跟步左搬攔，活步右沖拳。

Tactics: follow-step, deflect, parry the left palm and punch the right fist.

圖 17

動作： 1、甲左腳跟進半步，右腳隨之提起。同時，上體微右轉，左手向下、向右劃弧，經右前臂下方內旋伸出，掌心向外，虎口朝下，反手搬開乙的右掌；右拳屈肘抱於腰間，拳心向上（圖17）。

Movements: a. A. moves a half step forwards with the left foot and lift the right foot with it; at the same time, turns the upper body slightly to the right, draws the left palm in an arc downwards to the right, and rotates inwards while passing lower part of the right forearm and extends out, palm facing outwards and the tiger's mouth facing downwards, to fend off the right palm of B with his backhand, bends the right elbow and hold the right fist on the waist, the fist heart facing upwards (Fig. 17).

2、右腳向前落步成小弓步。同時上體左轉，右拳內旋沖打乙腹部，拳眼朝上；左手搬勢不變。目視對（東）方（圖18）。

b. Drops the right foot forwards to form a small bow stance, at the same time, turns the upper body to the left and rotates the right fist inwards to punch B at the abdomen, the eye of the fist facing upwards, keeps the left palm in the parrying position, looking at the opponent (the East) (Fig. 18).

圖 18

要點： 傳統太極拳稱拳法為"捶"，素有太極五捶之說。沖捶即是用拳向前沖打。沖拳時應與身法、步法協調一致，做到力由腰出，拳隨步落。

Key points: The fist technique is named as "pounding" in traditional Taijiquan and there are five kinds of pounding in Tai Chi. Punching means striking fist forwards; the punching should be coordinated with the bodywork and footwork so that the force originates from the waist and the punch follows the footwork.

（八）乙搂手沖捶 (圖 19、20)
B-hand block and punch fist

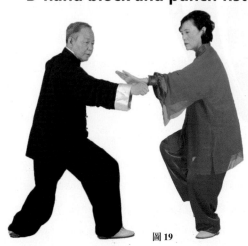

圖 19

招法: 活步左摟手，右冲拳。

Tactics: free moving of foot and left brush hand,punch right fist

動作: 1、乙在甲拳將至時，含胸收腹，向左轉腰，右腳提起。同時，左手經胸前下落，向左摟開甲右拳；右掌順勢握拳，收抱於右腰間，拳心向上（圖19）。

Movements: a. While the fist of A is approaching, B contracts chest and pulls in the abdomen, and turns the waist to the left and lifts the right foot; at the same time, moves the left palm downwards, through the chest to brush away the right fist of A to the left, clenching the right fist accordingly and hold on the right waist, the heart of the fist facing upwards (Fig. 19).

2、隨之，乙右腳前落，重心前移成小弓步。左掌摟勢不變；右拳內旋，立拳沖打甲腹部，拳眼朝上。目視對（西）方（圖20）。

b.Then, B drops the right foot forwards, and shifts the body weight forwards to form a small bow stance; while keeping the left palm in defense unchanged, rotates the right fist inwards to vertical fist, and punches it to the abdomen of A, the fist eye facing upwards, looking to the opponent (the West) (Fig. 20).

圖 20

要點: 太極拳格擋防守招法很多。習慣稱呼向上為架，向下為摟，向外為搬，向內為攔。

Key points: there are many techniques of the block in defense in Taijiquan. It is customary to call upwards as block high, downwards as brush, outwards as deflection, and inwards as parry.

(九) 甲換步左靠 (圖 21、22)
A-change steps and squeeze to the left(Fig.21,22)

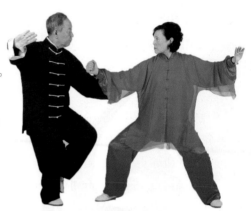

圖 21

招法: 換步進身，弓步托肘左肩靠。

Tactics: change steps and close body contact, bow stance, push elbow and squeeze with the left shoulder.

動作: 1、當對方擊來時，甲收腹縮身，重心後移，右腳收至左腳旁，提起左腳。同時上體右轉，左手前伸托住乙右臂肘關節；抽回右手舉於體側（圖21）。

Movements: a.While the opponent hit approaching, A pulls in the abdomen and retracts the body and shift the bodyweight backwards, retracts his right foot to the side of the left foot, and lifts the left foot; at the same time, turn the upper body to the right, and stretches the left hand forwards to grasps the elbow joint of B's right arm, withdraws the right hand levelly to the side of the body (Fig. 21).

2、隨之左腳上步，落於乙右腳後側，重心前移成側弓步。左手虎口向上，掌心向右，托舉乙右肘。重心下沈前移，用左肩擠靠乙右腋。甲乙皆側身朝南，目視對方（圖22）

b.then steps the left foot forwards and drops at the rear of B's right foot, and shift the bodyweight forwards to form a side bow stance; grasps the right elbow of B with the left hand, the mouth of the left hand facing upwards, palm facing to the right; lowers the body weight and move forwards, and with the left shoulder squeeze against the right armpit of B; Both A and B are sideways facing south, looking at each other (Fig. 22)

要點：靠也是太極拳八法之一，用身體擠壓對手，貼身發勁，不同於沖撞。

Key points: the squeezing technique is also one of the eight techniques of Taijiquan, which is to press the opponent with the body, exerting force while close contact to the opponent's body, which is different from a collision.

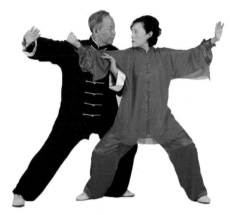

圖 22

（十）乙右貫拳伏虎 （圖 23、24）
B-sweep right side and punch and tame the tiger(Fig.23,24)

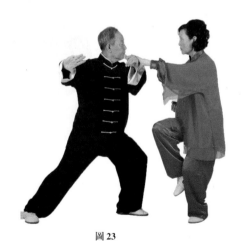

圖 23

招法：縮身繞步，貫拳擊打對方後腦。

Tactics: retract and circle step, punching the opponent on the back of the head.

動作： 1、在甲靠近時，乙縮身後坐，提起右腳。左手下採甲左前臂，右拳解脫後收至胸前，拳心向上（圖23）。

Movements: a. While A approaching, B sits back and lifts the right foot; with the left hand pulls A's left forearm, after the right fist is released, retract it to the chest, the heart of the fist facing upwards (Fig. 23).

2、上勢不停，乙右腳繞落至甲左腳後側，屈膝前弓成右弓步。右拳內旋，向右向前劃弧，貫打甲的後腦，拳眼斜向左下。目視對（西）方（圖24）。

b. Without stopping, B circles a step with her right foot and drops it at the rear of A's left foot, bending the knee to form a right bow stance, rotates the right fist inwards, and draw in an arc to the right and forwards to strike the back of A's head, the eye of the fist tilting downwards to the left, looking at the opponent(the West) (Fig. 24).

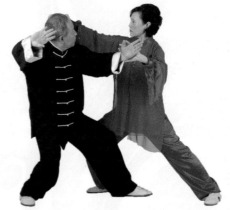

圖24

要點： 解脫時要把握好時機，與身法、步法密切配合。貫拳為武術中常用拳法。轉腰揮臂，拳內旋經體側向前劃弧擊打對方頭部，力點在拳面。

Key points: When neutralizing the oncoming force, you should get the timing right to cooperate closely with your bodywork and footwork. Side punching is a commonly used fist technique in martial arts. Turn your waist and swing your arms, strike your fist from the side of the body in an arc on the opponent's head. The force point is concentrating on the face of the fist.

（十一）甲馬步顶肘（圖25）
A-Horse stance jab elbow(Fig.25)

招法： 馬步下蹲，屈臂用肘尖頂撞對手。

Tactics: horse stance and squat down, bend the arm, and hit the opponent with the tip of the elbow.

動作： 甲急速坐腿閃身，右手經左臂下伸出，反手（掌心向右，虎口朝下）抄拿乙的左腕，向左採裂；左手掙脫後在胸前屈臂握拳，拳心朝下，屈膝下蹲成弓步或偏馬步，用肘尖頂撞乙的胸口。目視對方（圖25）。

Movements: A sits on his legs swiftly to dodge and stretches out his right hand from beneath his left arm, and with his backhand (palm facing to the right and tiger's mouth facing down), grab B's left wrist and pulls it to the left; after A releasing his left hand, bends his left arm and clench his left fist in front of his chest, the heart of the fist facing downwards, and bends knees to squat down to form a bow stance or a biased horse stance, and jabs B's chest with the tip of his elbow, looking at B (Fig. 25).

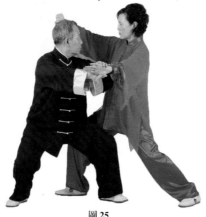

圖 25

要點： 閃身解脫與蹲身頂肘，要動作連貫，一氣呵成。

Key points: The movements of squatting down to dodge and jabbing the elbow should be smooth without any interruption. should be smooth without any interruption.

(十二) 乙轉腰推肘 (圖 26)
B-turn waist and push elbow(Fig.26)

招法: 轉腰橫推，使對方陷入背勢。

Tactics: turn waist and push horrizontally to make the opponent losing good posture

動作: 在甲肘頂來時，乙含胸收腹，坐腿縮身，使對方攻勢落空。隨之右拳鬆開，隨轉腰弓腿，向左橫推甲肘關節，使甲陷於背勢；乙左手掙脫後，舉於身體左後方。目視右手（圖26）。

Movements: While A's elbow approaching, B contracts her chest and abdomen, and retract and sit on her legs, so that the opponent's attack to be ineffective; then, unclenches her right fist, and with rotating of the waist moves her legs to form a bow stance, pushing A's elbow joint horizontally to the left, so that A loses his superior position; after releasing her left hand, B moves it to the left rear of the bodyside, look at her right hand (Fig. 26).

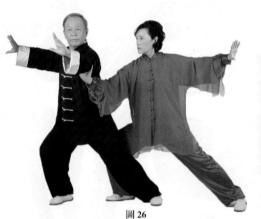

圖26

要點: 先縮身引進，使對方落空。再轉腰推肘, 使對手陷於被動。隨曲就伸，人剛我柔。

Key points: First, retract the body to bring in, to make the opponent's attack ineffective. Then rotates the waist and pushes the elbow to cause the opponent to fall into an inferior position. Stretching follows flexing, softness overcomes rigidity

(十三) 甲左披身捶 (圖 27)
A-Fists roll over body(Fig.27)

招法: 借勢走化，披身反擊撇拳

Tactics: take advantage of the posture to neutralize, strike with backhand fist

動作: 趁乙推肘之勢，甲上身右轉，重心右移，化解乙的攻勢。隨之身體返轉，重心左移成左弓步。以身帶臂，左手握拳，向左披身撇拳劈砸乙面部，拳心朝上，力點在拳背；右手屈臂附於左前臂上方，掌心朝下。眼看對手（圖27）。

Movements: Taking advantage of B's elbow push, A turn his upper body to the right and shifts the body weight to the right to neutralize B's offense, without stopping turns his body to the left to shifts his bodyweight the left to form a bow stance, then uses the body as driving force for the arm swing, clenches his left fist and chops to the left on B's face, the heart of his fist facing up, and the force point is concentrating on the back

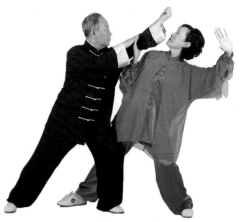

圖 27

of the fist; bends his right arm and attaches his right hand on the top of the left forearm, his palm facing down, looking at the opponent (Fig. 27).

要點: 引進落空，隨曲就伸，人剛我柔謂之走，我順人背謂之粘。體現出太極拳的攻防特色。

Key points: bring in, cause the opponent's attack ineffective, apply the technique, I stretch while opponent flex. When the opponent is rigid, I apply softness which is called walking force. I stick to the opponent without being separate which is called sticky. These applications manifest the offensive and defensive characteristics of Taijiquan.

（十四）乙托肘右靠（圖 28）
B-lift elbow and butt right(Fig.28)

招法：右手托舉對方左肘，側身逼近對方，右肩擠靠對方腋下。

Tactics: raise the opponent's left elbow with the right hand, approach the opponent sideways, and with her right shoulder presses and squeeze against the opponent's armpit.

動作：甲左拳劈來時，乙重心後移，閃身轉腰。隨之右手向上托舉甲的左肘，右腳前進半步，插入甲身後，屈膝前弓成側弓步。同時側身逼近對方，用右肩插入對方左腋下擠靠。左手仍平舉於身體後方。此時二人身體斜向南，並肩交疊站位（圖28）。

Movements: While A's left fist chopping approaching, B shifts the bodyweight backwards, and rotates her waist to dodge, without stopping with her right hand pushes the left elbow of the A upwards, and moves her right foot a half step forwards to insert it to the back of A's body, bends the knees to form a side bow stance; At the same time, approaching the opponent sideways inserts her right shoulder under the opponent's left armpit and squeezes downwards. The left hand is still raising flat behind the body, at this moment both A and B facing diagonally to the south and shoulder by the shoulder in an overlapping position (Fig.28)

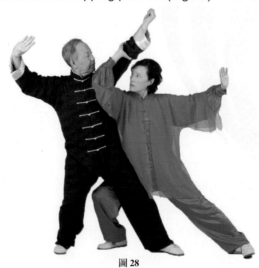

圖 28

要點： 乙屈膝側弓步擠靠時，左腳應適當滑步移動，調整位置，保持身體鬆順穩定。

Key points: When B bends her knee to adopt the side bow stance, and presses and leans against the opponent, her left foot is to slide appropriately to adjust her position to keep her body loose and stable.

（十五）甲左貫拳伏虎（圖 29、30）
A-sweep left side and punch and tame the tiger(Fig.29,30)

招法： 繞步至對方身後，左貫拳擊頭。

Tactics: circles step to the backside of the opponent and with his fist strikes on her head.

動作： 乙靠近時，甲重心右移，向右閃身。隨之右手抓住乙右腕向右採領。同時左腳提起，繞至乙右腿外側，重心前移成左弓步。左臂解脫後，左拳抽回經胸前內旋，向左、向前上方割弧，貫拳擊打乙頭部。力點在拳面，拳眼斜向右下。目視左拳（圖29、30）。

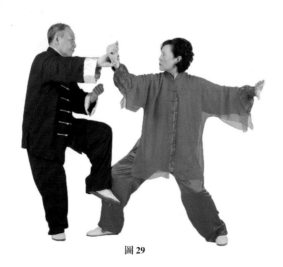

圖 29

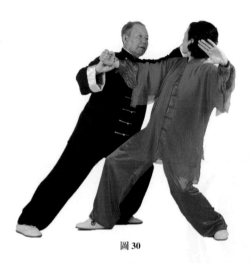

圖 30

Movements：While B approaching, A's shifts the body weight to the right and dodges to the right; without stopping with his right hand grabs B's right wrist and pull it to the right; at the same time, lifts his left foot, circles to the outside of B's right leg, and shifts his bodyweight forwards to form a left bow stance; after releasing his left arm, draws his left fist back and through in front of the chest rotates it inwards and draws in an arc to the left, forwards and upwards and strikes on B's head, The force point is concentrating on the face of the fist, the eye of the fist facing slanted downwards to the right, looking at his left fist (pictures29, 30).

要點： 在太極拳手法術語中，手向下牽引對方叫"採"；向後或向側後方牽引對方叫"領"叫"帶"。貫拳也是手法術語，指拳由後向前上方內旋劃弧擺動，打擊對方頭部，力點在拳面。

Key Points: in the terms of hand-technique in Taijiquan, with the hands pulling the opponent downwards is called "Cai"; pulling the opponent backward or to the sideway backward is called "leading" or "bringing". Guanquan is also a term of hand-technique, swing a fist in an arc from the back forwards and upwards, striking the opponent's head, the force point is concentrating on the face of the fist.

（十六）乙化打撇捶（圖 31、32）

B-neutralize opponent's force point and turn body and throw fist(Fig.31,32)

招法： 右拳先內旋攔截，化開對方。隨之披身外旋撇拳，劈打對方頭部。

Tactics: first rotates the right fist inward to intercept, neutralize the opponent's attack. Then turns her body and rotates her fist, chops her fist on the opponent's head.

動作： 1、甲左拳將擊到時，乙坐腿閃身，左手由後向前經右前臂下方穿出，反手（掌心向左，姆指向下）抓拿甲的右腕，向左摘開甲的右手；繼而向右轉腰，兩臂撐開，右手握拳屈肘內旋，向右攔截甲的左拳。目視右側（圖31）

Movements: a.While A's left fist approach, B sits back on her leg to dodge, pierces out her left hand from back to the front through under her right forearm, with her backhand (palm to the left, thumb downwards), grabs A's right wrist and pushes away A's the right hand to the left; then turning her waist to the right, spread her arms apart, and clench her right fist and bends her elbow while rotating inwards to intercept A's left fist, looking to the right side (Fig. 31)

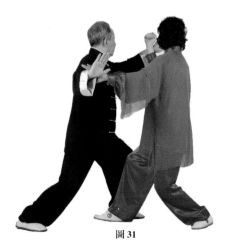

圖 31

2、上勢不停，左腿蹬伸，右腿屈弓成右弓步。同時向左轉腰，右臂外旋，用拳背向前撇打甲頭部。眼看前（西）方（圖32）。

b.Without stopping, stretches her left leg, and bend her right leg to form a right bow stance; at the same time, turns her waist to the left, rotates her right arm outwards, and use the back of the fist to punch forwards to the head of A, looking forwards(the west) (Fig. 32).

要點： 乙的招法是左手抄拿對方，解脫控製；右拳化打，先防後攻。必須與轉腰旋臂，重心移動協調配合，才能保證招法準確有效。

Key points: Key points: B's tactic is to grab the opponent with the left hand to release being controlled; using her right fist to neutralize the opponent's attack and strike it, to defend first, then attack. It must be well-coordinated with the rotation of the waist and arms, and the movement of her bodyweight to ensure that the tactic is accurate and effective.

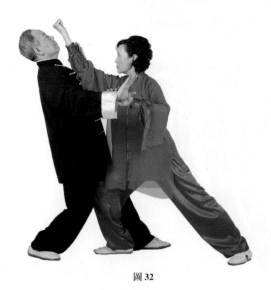

圖 32

(十七) 甲提手上勢 (圖 33、34)
A-raise hand and step up(Fig.33,34)

招法: 撤步左推手，換步右劈肩。

Tactics: Withdraw the step and push the hand to the left, and change the step to chop the shoulder to the right.

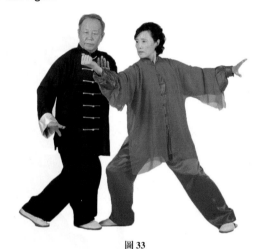

圖 33

動作: 1、當乙拳下劈時，甲重心後移。坐腿閃身，左拳變掌，沾住乙的右肘（參見圖32）。隨之左腳後撤一步，上體右轉，左手內合，向右推按乙右臂，使乙拳落空（圖33）。

Movements: a.While B's fist strikes downwards, A's shifts the bodyweight backward, and sits back on his legs to lean backward, and unclenches his left fist to stick to B's right elbow (Fig. 32). Then withdraws his left foot one step backward, and turns his upper body to the right, the left-hand moves inward and push and press B's right arm to the right to make B's fist attack empty (Fig. 33).

2、隨之上體左轉，重心左移，右腳向前踏出半步，成右虛步或半馬步。右手從自己的左前臂內側提起，用掌外沿（小指側）劈擊乙右肩，掌心向左。目視對（東）方（圖34）

b.Turning his upper body to the left, shifts his body weight to the left, and steps his right foot a half step forwards to form a right empty stance or a half-horse stance; lifts his right hand from the inner side of his left forearm, and with the outer edge of the palm (the side of the little finger)chops onto B's right shoulder, palm facing to the left, looking at the opponent(the East) (Fig. 34)

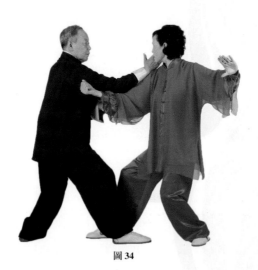

圖 34

要點：甲撤左步、換右步時，要視對方距離決定步幅大小。定勢成虛步時右腳尖可以翹起，也可以全腳著地。

Key Points: When A withdraws the left foot backwards and changes to the right foot forwards, the length of the stride should be determined according to his distance to the opponent. when adopting an empty stance in a fixed posture, the right toes can be either tilted upwards or with the complete foot on the ground.

（十八）乙轉身化按（圖35、36）

B-turn body and neutralize and press(Fig.35,36)

招法： 坐腿轉腰，化開對方攻勢。隨之反攻前按。

Tactics: sit on her legs and turn the waist to neutralize the opponent's attack, then to press forwards as a counterattack.

動作: 1、甲掌劈來時，乙坐腿轉腰，雙手上舉掤住甲右臂，右手粘甲腕，左手粘甲肘，順勢向右後方引化，使甲劈掌落空。目視右（北）側（圖35）。

Movements: a.While the back of A's palm approaching, B sits on her leg and turns her waist, with her two hands wards off upwards A's right arm, and sticks her right hand to A's wrist, sticks her left hand to A'elbow; taking advantage of the posture to lead it to her right rear, so that A's the palm chopping fails empty, looking to the right side(the North) (Fig. 35).

2、隨之轉腰向前，屈膝前弓成右弓步。雙手控製甲右臂向前推按。目視前（西）方（圖36）。

b.Turning her waist to the front, bend her knees forwards to for a right bow stance; with both hands control the right arm of A and pushes it forwards, looking to the front (the West)(Fig. 36).

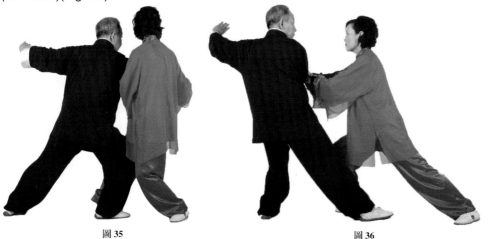

圖 35　　　　　　　　　　圖 36

要點: 乙向後引化與向前推接時，前（右）腳可活步移動，隨引化提腳內收，隨推按移腳前落。

Key Points: When the B leads backward to neutralize and pushes forward, the front (the right) foot be moved freely, with the leading move to retract foot, and with the pushing and pressing move to drop the right foot forwards.

（十九）甲摺疊冲捶（圖 37、38）
A-fold and punch(Fig.37,38)

招法: 右前臂翻轉摺疊圧製對手，隨之右拳向前沖打。

Tactics: flip and fold the right forearm to control the opponent, and then punch forwards with the right fist.

動作: 1、乙按來時，甲坐腿向左轉腰，右臂掤住乙雙手後引（參見圖36）。隨即向右轉腰，右前臂摺疊翻轉，壓製乙右腕，右手握拳，拳心向上；左手控製乙右肘。同時重心後移，左腳屈膝提收，使乙完全落空（圖37）。

Movements: a.While B pressing approaching, A sits on his leg and turns his waist to the left, and ward off B's hands with his right arm and pulls backwards (Fig. 36); then turning his waist to the right, folds and flips his right forearm to suppress B's right wrist, clench his right fist with the heart of the fist facing upwards, with his left-hand controls B's right elbow; at the same time, shifts his body weight backwards, and bends his left foot and raises it, causing B attack completely ineffective (Fig. 37).

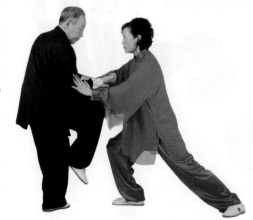

圖 37

2、随即甲右脚前落，重心前移成弓步。同时右拳向前冲打乙胸部，拳心朝上，力点在拳面；左手仍扶于乙右肘助力。目视对（东）方（圖38）

b.Immediately, A drops his right foot on the ground in the front and shifts his bodyweight forwards to form a bow stance, at the same time, punches his right fist forwards on to B's chest, the heart of the fist facing up, and the force point is concentrating at the face of the fist; the left hand is still blocking B's right rib to help, looking at the opponent(the East)(Fig. 38)

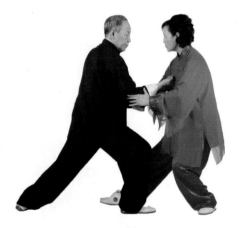

圖 38

要點：摺疊時，要坐腿轉腰，屈肘旋臂，含胸收腹，周身完整一體。落腳沖拳要根據距離，控製步幅，定勢時步型可弓步可馬步。

Key points: When folding, you should sit with your leg and turn your waist, bend your elbow and rotate your arm, and contract your chest and abdomen. The whole body should act like one. When dropping the foot on the ground and punch out the fist, the length of the stride should be controlled according to the distance to the opponent. While adopting fixed posture, the stance can be a bow stance or a horse stance.

（二十）乙搬手沖捶（圖 39、40)
B-deflect hand and punch fist(Fig.39,40)

招法： 右腳活步，左搬手右沖拳。

Tactics: makes a free moving of the right foot, deflect with her left hand and punch out her right fist.

動作： 1、甲拳打來時，乙含胸收腹，重心後坐，前腳屈膝收提。同時左手移到甲右腕內側，向左搬開甲右臂；右手握拳收至腰間。目視左手（圖39）。

Movements: a.While A punch approaching, B contract his chest and abdomen sits backwards with her bodyweight, and lifts her front feet with bending the knees; at the same time, moves her left hand to the inside of A' right wrist, and deflects away A's right arm to the left, clench her right fist and moves it to the waist, looking at her left hand (Fig. 39).

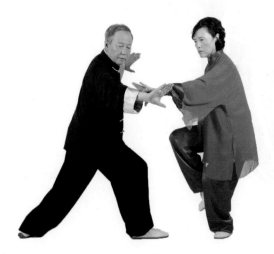

圖 39

2、上勢不停，右腳前落原處，屈膝前弓成右弓步。同時右拳立拳（拳眼向上）沖打甲胸部；左手仍外搬甲右臂，掌心向外，虎口朝下。目視前（西）方（圖40）。

b.Without stopping, drops her right foot forwards to the ground, bends her knee to form a right bow stance; at the same time, punches her right fist vertically (eye of the fist facing upwards) to the chest of A, while her left hand keeping deflecting away A's arm, her palm facing outwards, and the tiger's mouth facing downwards, looking forwards(the West)(Fig. 40).

要點：乙右腳隨重心移動收提前落，右拳自腰間向前沖打，做到上下相隨，力從腰發。

Key Points: With the shifting of the bodyweight, A lifts her right foot first, then drops it forwards to the ground, and her right fist punches forwards from the waist, so as upper limbs and lower limbs move in harmony, and force originates from the waist.

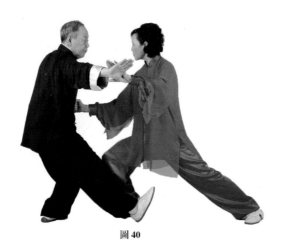

圖 40

（二一）甲搬手橫挒（圖 41、42）

A-deflect hand and pull horrizontally (Fig.41,42)

招法: 繞上步，搬手橫挒（捯）。

Tactics: circle step, deflect hand horizontally

動作: 1、乙右拳打來時，甲坐腿縮身，含胸收腹（參見圖40），上體左轉，提起右腳。同時左手落至乙右腕內側，前臂內旋，掌心朝外，虎口張開，反手向左搬開乙右臂；右手粘住乙右手。目視對方（圖41）。

Movements: a.While B's right fist approaching, A sits on his leg and retract his body, contract his chest and abdomen, and turns his upper body to the left, and lifts his right foot; at the same time, drops his left hand to the inside of B's right wrist, and rotates his forearm inwards, his palm facing outwards, the tiger's mouth opening, and with his backhand pushes away B's right arm to the left, and sticks his right hand to B's right hand, looking at the opponent(Fig. 41).

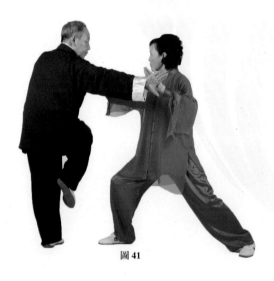

圖 41

2、 上動不停，甲右腳繞步落於乙右腳後側，屈膝前弓成右弓步。同時上體前傾，左手握住乙右腕外撐；右臂內旋前壓，向右前方橫挒乙的胸部頸部，此時甲上體左轉，朝向東北，乙朝向西南(圖42)。

b.Without stopping, A circles a step with his right foot to the side and rear of B's right foot, and bends his knee forwards to form a right bow stance; at the same time, leans his upper body forwards, with his left hand grabs B's right wrist and props it outwards, rotates his right arm inwards and pressing it forwards, press B's chest and neck forwards to the right horizontally, causing the upper body of A to turn left, facing the Northeast, and B facing the Southwest (Fig. 42).

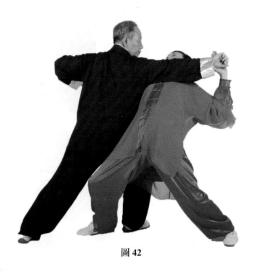

圖 42

要點： 挒音lie（四聲），是太極拳重要八法之一。指橫向撕打、扭轉（捩）、壓迫等招法。本勢橫挒既有壓迫，也有扭轉態勢。

Key Points: Lie (the fourth tone in Chinese) is one of the eight important techniques of Taijiquan. It refers to tactics such as horizontal tearing, twisting, and pressing, etc. The horizontal tearing in this posture is not only a pressing to the opponent, but also it can reverse the situation.

(二二) 乙野馬分鬃 (圖 43、44、45)
B-Wild Horse Parts Manne(Fig.43,44,45)

招法: 撤步抽身，換步右採左分靠。

Tactics: withdraw a step back, change steps and tear to the right, and squeeze to the left.

動作: 1、不待甲逼近，乙迅速右腳撤步至左腳後，身體向後脫身左轉。同時右臂內旋脫開甲左手，向下、向左劃弧，向上捌起甲右臂。目視右手（圖43）。

Movements: a.Before A approaches, B withdraws quickly his right foot to behind her left foot, and leans back and turns to the left to release; at the same time, rotates her right arm inwards to release from the left arm of A, draws it in an arc downwards to the left, and wards off the right arm of A upwards, looking at her right hand (Fig. 43).

2、上勢不停，乙上體右轉，提起左腳。右手反手（掌心向外，虎口朝下）拿住甲右腕向後牽引，左臂伸至甲右腋下（圖44）。

b.Without stopping, B turns her upper body to the right and lifts her left foot; with her backhand of the right hand (palm facing outwards, tiger mouth facing down), grabs the right wrist of A and drags it backwards, and extend her left arm under the right armpit of A (Fig. 44).

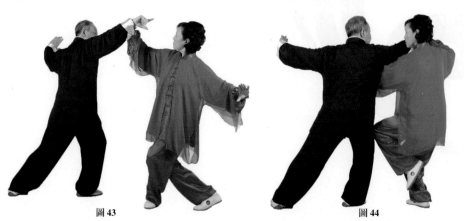

圖 43　　　　　　　　　　　　　　圖 44

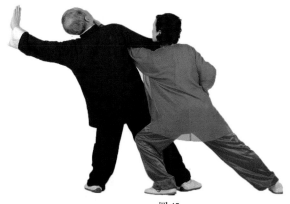

圖 45

3、左腳隨即前落至甲右腿側後，屈膝前弓成左弓步。同時右手下採甲右臂，左臂向前向左分靠甲右肋，力點在前臂，掌心斜向上。上體側向西北，目視對（西北）方（圖45）。

c.Immediately drops her left foot to the right and rear of A's the right, and bend the knee forwards and to form a left bow stance; at the same time, with her right hand tears A's right arm downwards, and with her left arm squeeze against A's right rib forwards to the left, the force point is concentrating on her forearm, her palm tilting upwards, her upper body facing Northwest, looking at the opponent (the Northwest)(Fig. 45).

要點：靠是身體擠壓攻擊，力點各不相同，有肩靠、背靠、胸靠、臂靠之分。本勢力點在左臂，向前向左擠靠。

Key Points: Kao is to attack with the body squeezing. There are different force points in different tactics, including shoulder squeeing, back squeezing, chest squeezing, and arm squeezing. The force point in this posture is on the left arm, squeezing forwards to the left.

第二段　Section 2

(二三) 甲右貫拳伏虎（圖 46、47）
A-sweep right side and punch and tame the tiger(46,47)

招法：繞步至對方身後，貫拳擊頭。

Tactics: circles step to the backside of the opponent and with his fist strikes on her head.

動作: 1、乙將靠近時，甲左手在胸前反手（掌心向外，虎口朝下）採拿乙的左腕。隨即提起右腳，上體右轉，右拳外旋解脫抽回，收至腰間。頭隨體轉，注視对方（圖46）。

Movements: a. When B approaching, A bends the joint of his left hand in front of his chest and with backhand (the palm facing outwards, the tiger's mouth facing downwards) grabs B's left wrist and tears; immediately lifting his right foot, turns his upper body to the right, and rotates his right fist outwards to dodge and withdrawsíng back to his waist, his head moves with the tuning of his trunk, looking at the opponent(Fig. 46).

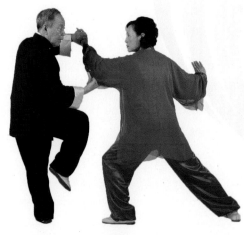

圖 46

2、上勢不停，甲右腳繞上步落在乙左腳後外側，屈膝前弓成右弓步。同時右拳內旋外擺，向前貫打乙頭部，力點在拳面，拳眼斜向左下方。目視對（東北）方（圖47）。

c.Without stopping, A circles a step with his right foot forward and drops it at of the outer rear of B's left foot, bending his knees to form a right bow stance; at the same time, rotates his right fist inwards and swings outwards to forwards on B's head, the force point concentrating on the face of his fist, and the eye of the fist tilting downwards to the left, looking to the opponent(the Northeast)(Fig. 47).

要點：甲右拳解脫抽回時前臂外旋；向前貫打時前臂內旋。提腳上步時上體右轉；弓步貫拳時上體左轉。

Key Points: A rotates his forearm outwards while releasing his right fist and withdrawing; He rotates his forearm inwards when punching it forwards. He turns his upper body to the right when lifting his foot and stepping forwards. He turns his upper body to the left when adopting the bow stance punching his fist.

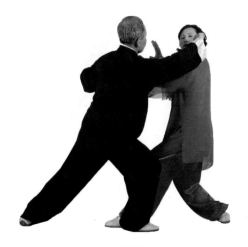

圖 47

(二四) 乙轉身大捋 (圖 48、49、50)
B-Turn Body With Full Roll Back(Fig.48.49.50)

招法: 繞行步轉身左捋。

Tactics: circle step and deflect to the left with turning of the body.

動作: 1、甲拳擊來時，乙坐腿閃身（參見圖47），左腳前移半步，腳尖外擺，屈膝前弓，向左轉腰。同時左手內旋翻腕，反手採拿甲左腕向左牽捋。頭隨體轉，目視對（西南）方（圖48）。

Movements: a.While A's fist approaching, B sits back on her leg to dodge, moves her left foot a half step forwards, toes pointing outwards, bends her knees to form a bow stance, and turns her waist to the left; at the same time, turns her wrist with the inward rotation of her left hand, with her backhand grabs A's left wrist with the backhand and drags to the left, her head turns with the rotation of her waist, looking at the opponent(the Southwest)(Fig. 47 and 48).

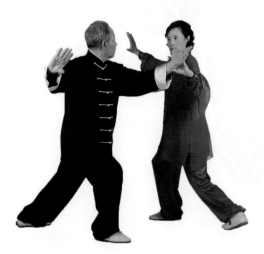

圖 48

2、上勢不停，乙右腳隨即沿弧線向左前方繞行一大步，腳尖內扣。身體隨之向左轉，左手牽甲左腕繼續左捋，右前臂外旋滾肘，沾附甲左臂外側助力左捋。此時甲左腳隨之沿弧線向前一大步，腳尖外擺，屈膝前弓，上體左轉。二人目光對視（圖49）。

b.Without stopping, B moves her right foot in a big s-step forwards to the left, toes buckled inwards, then turns her body to the left, with her left hand grabbing A's left wrist and continuing to deflect to the left, rotates her right forearm outwards and rolls her elbow to stick to the outer side of A's left arm assisting the left deflection, at this time, A moves his left foot a big s-step forwards along the line of the arc, toes swinging outwards, bends his knee to bow forwards, and turns his upper body to the left, both A and B looking at each other (Fig. 49).

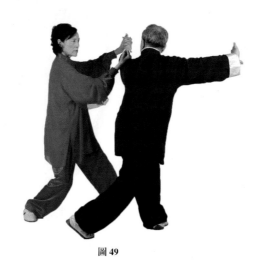

圖49

3、繼上勢，乙左腳向身後（西）退一大步，上體左轉，右腿屈弓成右弓步。兩手向左捋勢不變。此時甲隨之沿弧線向前再繞上一大步，腳尖內扣，屈膝前弓。目光對視，此時甲乙二人位置左右（東西）對調（圖50）。

c.Continuously, B steps a big step backwards (the West) with her left foot, turns her upper body to the left, and bends her right leg to form a right bow stance, keeping left deflection with both hands unchanged; at this time, A follows B to move a big step forwards along the line of the arc again, his toes buckling inwards, and bends his knee to bow forwards, both A and B looking at each other, and at this moment the positions of A and B are reversed (Fig. 50).

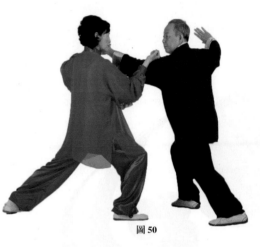

圖 50

要點: 甲乙二人沿弧線行步，乙捋甲隨。乙經過左擺、右扣、左退三步，甲經過左擺、右扣繞行兩步。位置已經互換。

Key Points: A and B step up along the line of the arc, while B deflecting and A following. B makes three steps, namely left swing, right buckling, and left retreating. A walks two steps along the arc, namely left swinging and right buckling. Thus the positions of A and B have been swapped.

(二五) 甲上步左靠 (圖 51)
A-step forwards and squeeze to the left(Fig.51)

招法: 上步插襠，左肩擠靠。

Tactics: step up and insert the crotch, press and squeeze with the left shoulder.

動作: 1、甲順乙捋勢沿弧線繞行兩步。（參見上動圖49、50）。

Movements: a.Following the momentum of B's deflection, A walks two steps along the line of the arc, refer to the above movement (Refer to the upper moving pictures 49 and 50).

2、甲順勢左腳經乙右腳內側，向前上步插入乙襠內，屈膝前弓。同時右掌附按在左上臂內側助力，用左臂和左肩擠靠對方。目視對（西）方（圖51）。

b.Steps his left foot forwards passing through the inside of B's right foot, and inserts into B's crotch; at the same time, touches his right palm on the inside of his left upper arm, bends his knee and bow forwards, and press and squeeze against the opponent with his left arm and left shoulder, looking to the opponent(the West)(Fig. 51).

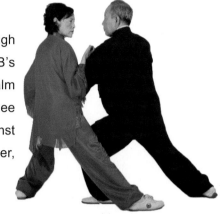

圖 51

要點： 甲上步速度、步幅、落點皆要隨乙行步捋勢而定，隨曲就伸，不丟不頂。擠靠時步型可弓步可馬步。

Key Points: The stepping speed, stride length, and dropping point of A should be adapted to B's walking steps and the force of B's deflection. The rule here to follow that I stretch while opponent flexes and neither separate from nor make forcible contact with the opponent. While applying to press and squeeze against, either bow stance or horse stance can be applied.

（二六）乙繞步推按 （圖 52、53）
B-circle steps and pushand -press (Fig.52,53)

招法： 繞上步，雙手前按。

Tactics: circle step and press forward with both hands

動作： 1、乙坐腿縮身，右腳繞步落到甲左腳內側。腳尖外擺。同時右拳變掌按在甲的右腕部；左手按在甲右肘，隨上體右轉，向右化開甲的靠勢（圖52）。

Movements: a.B sits on her leg and retract her body, circles her right foot, and drops at the inside of A's left foot, toes swinging outwards; at the same time, unclench her right fist and presses on A's right wrist, presses her left hand on A's right elbow, and turns her upper body to the right to neutralize the leaning force of A

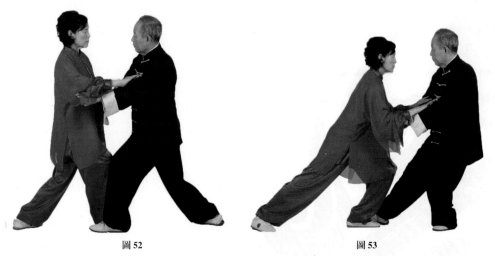

圖 52　　　　　　　　　　　　　　圖 53

　　2、上勢不停，乙左腳再前上一步，插入甲襠內，屈膝前弓成左弓步。同時兩掌 位置不變，向前推按甲的右前臂。目視前（東）方。甲隨之左腳後退一步，坐腿閃身（圖53）。

4.Without stopping, B takes another step forwards with her left foot and inserts into A's crotch, bends her knee to form a left bow stance; at the same time, without changing the position of her two palms, pushes and presses A's right forearm forwards, looking forwards(the East). Then A moves his left foot a step backwards and sits on his leg to dodge(Fig 53).

　　要點： 乙繞步推按時，先向右化，再向前按，與身法、步法協調配合。

Key Points: When B circles her step and pushes and presses, she is to turn to the right to neutralize first, then presses forward, the bodywork and footwork are to coordinate with each other.

(二七) 甲十字蹬腳 (圖 54)
A-cross kick(Fig.54)

招法: 兩掌分撐, 右腳前蹬。

Tactics: Cross hand and kick forwards with righ foot.

動作: 甲重心後移, 使乙落空。隨之左手向上抄至乙右腕內側, 兩臂同時內旋, 兩掌向外撐開乙的兩手, 高與肩平。同時右腿屈膝提起, 右腳向前蹬踹乙小腹。目視前方 (圖54)。

Movements: A shifts his bodyweight backwards to cause B's attack ineffective; then moves his left hand upwards to the inside of B's right wrist, rotates both arms inwards at the same time, and with his both palms separates B's two hands outwards, his palms at shoulder-height; at the same time, bends his right leg and lifts the right knee, and his right foot kicks forwards on B's lower abdomen. Look ahead (Figures 54).

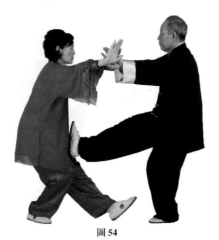

圖 54

要點: 蹬腳時, 右腿由屈而伸, 腳尖上勾, 力在腳跟。兩手左右撐開, 與前蹬腿成十字形。

Key Points: While kicking, his right leg is to stretch from the bending status, toes hooking upwards, the force point concentrating on his heel. Both hands are separated left and right respectively to form a cross with the front kicking leg.

(二八) 乙換步指襠捶 (圖55、56)
B-change steps and strike groin with fist(Fig.55,56)

招法: 換步左摟手，右沖拳

Tactics: change step and brush left and punch rith fist

動作: 1、當甲右腳蹬來時，乙坐腿收腹縮身，使甲蹬空（參見圖54）。隨之左手繞經甲腕內側下摟，向左撥開甲右小腿；右掌上舉至頭側（圖55）。

Movements: a.While A kicks on his right foot approaching, B sits on her leg and pulls in her abdomen to retract to cause A's kick ineffective; then brushes her left hand downwards passing through the inside of the A's wrist, and fend off A's right calf to the left, raises her right palm upwards to the side of the head (Fig.55).

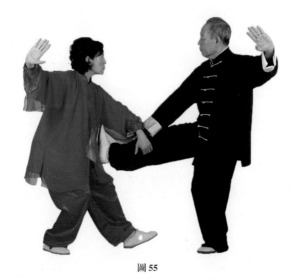

圖 55

2、上勢不停，乙左腳後收半步至右腳內側，身體左轉，右腳向前上步，屈膝前弓。同時右掌經腰間握拳，向前沖打甲襠部，拳眼朝上；左掌擺舉至頭側上方。目視對方（圖56）。

b. Without stopping, B retracts her left foot a half step to the inside of her right foot, turns her body to the left and steps her right foot forwards and bends her knee to bow forwards; at the same time, clenches her right fist and through the waist punches forwards to B's crotch, the eye of her fist facing upwards, and moves her left palm to the upper side of her head, looking at the opponent (Fig. 56).

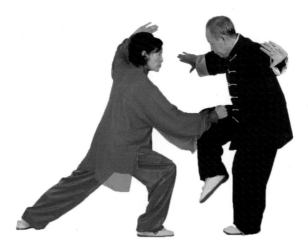

圖 56

要點：乙換步的時機和步幅要視具體情況靈活處置，收腳可大可小，上步可弓可馬，以得機得勢為準。

Key points:Key Points: The timing and stride length of the B change of step should be flexible depending on the specific situation, the closing foot can be large or small, the upper step can be bow stance or horse stance, subject to the opportunity and momentum.

（二九）甲採手橫挒（圖 57、58）
A-grab hands and pull horizontally(Fig.57,58)

招法: 落腳採手，上步橫挒。

Tactics: drop step and grab hands downwards, step up and hit horizontally.

動作: 1、乙右拳擊来时，甲收脚收腹缩身，使乙落空（参见圖56）。随之右脚收落至左脚内侧，脚前掌着地，屈膝下蹲，上体右轉。右手内合，採住乙右腕；左手粘在乙右肘外侧，助勢下採。眼注视右手（圖57）。

Movements: While B's right punch approaching, A withdraws his foot back and pulls in his abdomen and retracts, to cause B's attack ineffective, then drops his right foot at the inside of B's left foot, the sole of his forefoot on the ground, bending his knee to squat down, and turns his upper body to the right, and closes his right hand downwards to grabs B's right wrist, sticks his left hand to the outside of B's right elbow to assist the downward pressing, looking at his right hand (Fig. 57).

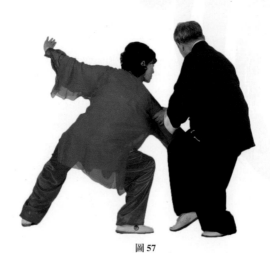

圖 57

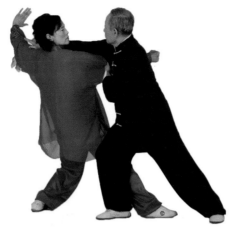

圖 58

2、隨之，甲右腳向前上步，落在乙右腳側後方，屈膝前弓。同時上體前傾左轉，右臂內旋前壓，橫置乙胸前，反臂握拳，拳心朝右，向左橫捌（挒）；左手仍附在乙右肘外側，助力扭轉。目視前（西）方（圖58）。

Then A steps his right foot forwards and drops at the side of B's right leg rear, bending his knee to bow forwards; at the same time, leans his upper body forwards and turns to the left, rotates his right arm inwards, and presses forwards to the in front of B's chest, clenches his right fist with back arm, the heart of his fist facing to the right and hits horizontally to the left and his left hand is still stuck on the outer side of B's right elbow to assist twisting, looking forwards(the West)(Fig. 58).

要點： 橫捌（挒）時，甲右臂向左前方用力，左掌向右後方助力。使乙向左扭轉後倒。

Key Points: While hitting horizontally, the right arm of A exerts force forwards to the left, and the left palm is to press backwards to the right rear to assist which makes B to turn to the left, then fall.

(三十) 乙玉女穿梭 (圖 59、60、61)
B-Jade Maiden Working Shuttles (Fig.59-61)

招法： 退步脫身，右掤左架，右推掌。

Tactics: Step backwards to dodge, ward off right and block left and push the right palm forwards.

動作： 1、甲攻來時，乙坐腿仰身，右腳向後速退一步。隨之右前臂上舉，右拳變掌向上掤開甲右臂（圖59）。

Movements: a.While A's attack approaching, B sits on her leg and leans her upper body backwards, immediately withdraws her right foot one step backward, then raises her right forearm, unclench her right fist to ward off upwards A's right arm (Figure 59).

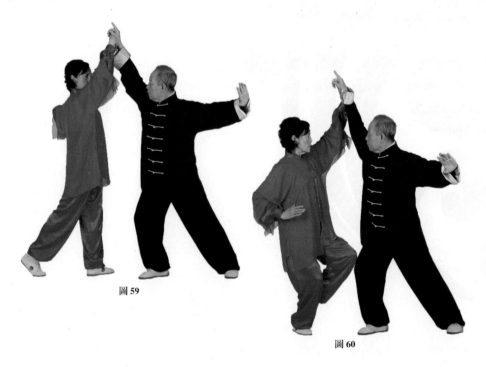

圖 59

圖 60

2、隨之，左腳提起，上體右轉。同時左手從右臂下穿出，內旋翻掌向上架開甲右臂；右掌收至腰間（圖60）。

b.Then lifts her left foot and turns her upper body to the right; at the same time, pierces out her left hand from under the right arm and rotates her left palm inwards and blocks away A's right arm upwards, retracts her right palm to the waist (Fig. 60).

3、上勢不停，乙左腳上步落在甲右腳外側，屈膝前弓成左弓步。同時右掌前推甲的胸部，掌心朝前；左掌掤架甲前臂之勢不變。目視前（東）方（圖61）。

c.Without stopping, B steps her left foot forwards, bending his knee to form a bow stance; at the same time, pushes her right palm forwards to A's chest, her palm facing forwards, the force of B's left palm to block A's forearm remains unchanged, looking forwards(the East)(Fig. 61).

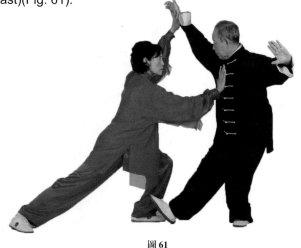

圖 61

要點：乙退步脫身要及時，避免陷入背動不可走化境地。

Key Points: when B retracts step and wards off to dodge, it must be in time to avoid losing advantage in posture which might not be possible to neutralize.

(三一) 甲摟手撇捶 (圖 62、63)

A-brush hand and turn body and smash fist(Fig.62,,63)

招法: 坐腿轉腰，左摟手，右撇拳。

Tactics: sit on leg and turn waist around, brush left hand and smash right fist with fist's upwards).

動作: 1、乙右掌擊來，甲坐腿含胸，上體左轉，用左手摟開乙右掌。眼看左手（圖62）。

Movements: a.While B's right palm hitting approaching, A sits on his leg and contracts his chest, turns his upper body to the left, and with his left hand grabs away B's right palm, looking at his left hand (Fig.62).

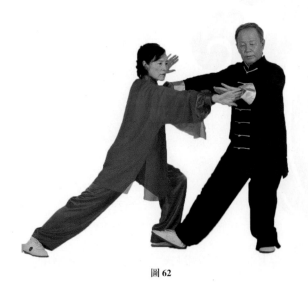

圖 62

2、隨之，右腿屈膝前弓成右弓步。同時右手脫開乙的左手，握拳繞到乙左臂內側，向前劈擊乙的頭部，拳心朝上，力點在拳背，目視對（西）方（圖63）。

b.Then, A bends his the right knee forwards to form a right bow stance; at the same time, releasing his right hand from B's left hand, clenches his right fist circles around to the inside of B's left arm, and chops forwards onto B's head, the heart of his fist facing upwards, the force point concentrating on the back of the fist, looking at the opponent(the West)(Fig. 63).

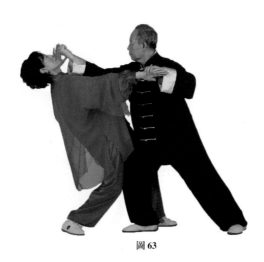

圖 63

要點：劈拳指拳自上向下的擊打招法，可以立拳下劈（拳眼朝上），也可以平拳下劈（拳心向上）。本勢為拳心向上平拳下劈，也稱撇拳。

Key Points: Chopping fist refers to a top-down hitting technique of fist, can chop downwards either with a vertical fist (eye of the fist facing upwards) or a flat fist (with the heart of the fist facing upwards). In this posture, it is a flat fist that chops downwards with the fist's heart up and, also known as the smashing fist(Pie Quan).

(三二) 乙白鶴亮翅 (圖 64、65)
B-White Crane Flashes its Wings(Fig.64,65)

招法： 左摟右掤，腳踢對方。

Tactics: brush left and ward off right, kick the opponent.

動作: 1、甲右拳劈來時，乙坐腿閃身，左手向內、向下、向左摟開甲右拳；右手繞至甲左臂內側，掌心向內，向上掤架甲左臂（圖64）。

Movements: a.While A's right fist approaching, B sits on her leg to dodge, with her left hand brushes inwards, downwards to the left to block away from A's right fist, and her right hand circles to the inner side of A's left arm, palm facing inwards to ward off A's left arm upwards(Fig.64).

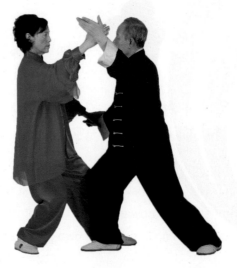

圖 64

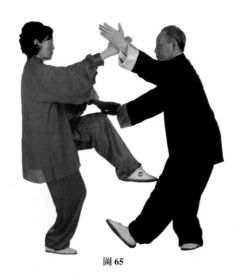

圖 65

2、隨之，乙右足向前跟步移動，提起左腳用腳尖踢擊甲右膝。目視前（東）方（圖65）。

b.Then, her right foot follows forwards, and lifts her left foot, and kicks her left foot with the toe forwards to A's right knee, looking forwards(the East)(Fig. 65).

要點：跟步是太極拳常用步法。後腳向前移動半步，接近前腳。本勢跟步步幅視二人距離而定，以踢腳不空不過為準。

Key Points: Follow-step is common footwork in Taijiquan Move the back foot forwards a half step, approaching the front foot. The stride length of follow-step in this posture depends on the distance between the two persons, the criteria is to ensure the kick neither empty nor too excessive.

(三三) 甲纏臂左靠 (圖 66、67、68)
A-twining arm and squeeze to the left(Fig.66-68)

招法: 右摟左纏,弓步肩靠。

Tactics: brush right and twist left, squeeze with shoulder with bow stance.

動作: 1、甲坐腿閃身(參見圖65)。隨之,右腳向左活步移動,腳尖外擺,上體右轉,重心前移。同時右手纏繞至乙左臂內側,向下向右摟開乙左腿;頭隨體轉(圖66)。

Movements: a.A sits on his leg to dodge, then makes a free moving of the right foot to the left, toes swing outward, turns his upper body to the right, and shifts his bodyweight forwards; at the same time, the right hand wraps around to the inside of B's left arm to brush downwards to block away B's left leg, his head moves with the tuning of his body(Fig. 66).

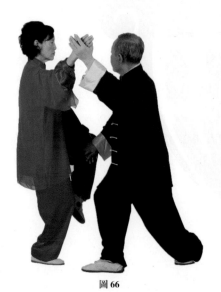

圖 66

2、上勢不停，甲左腳上步，落至乙右腳後側。左手粘附乙右腕向右、向下纏繞，左臂斜置體前，擠壓乙的右臂。頭隨體轉，目視右（北）側（圖67）。

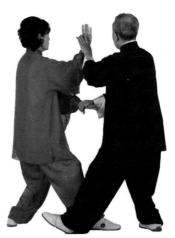

圖 67

b.Without stopping, A steps up his left foot and drops at the side and rear of B's right foot, sticks his left hand to B's right wrist and twist it downwards to the right and, the left arm is in front of the body obliquely, pressing B's right arm, his head moves with the tuning of his body, looking to the right (the North)(Fig. 67).

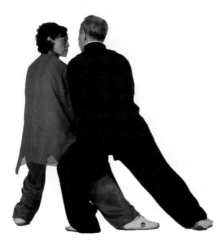

圖 68

3、甲右手附於左肘內側，屈膝前弓，重心前移，成左弓步。用左肩擠靠乙右肩。目視前（西北）方（圖68）。

c.A sticks his right hand to the inner side of B's left elbow, and bends his knee to bow forwards, and shifts his bodyweight forwards to form a left bow stance, presses and squeeze with his left shoulder against B's right shoulder, look forwards(the Northwest)(Fig. 68).

要點：甲活步右摟膝，上步左纏臂，弓步左肩靠，應動作連貫，一氣呵成，周身配合。定勢時，甲繞至乙的側後方，二人肩部貼緊。甲步型可弓可馬。

Key Points: A makes a free moving step and steps up, twins to the left, squeezes with his left should in bow stance. These movements should be smooth without any interruption, and the whole body should be well coordinated. When adopting fixed posture, A circles to the side and rear of B, and the shoulders of the two are stuck tightly together. The foot form of A can be a bow stance or a horse stance.

(三四) 乙繞步撅臂 (圖 69、70)
B-circle step and pouting with arm(Fig.69,70)

招法: 拿腕繞步，滾肘撅臂。

Tactics: grabs wrist and circle step, roll elbow and pout arm.

動作: 1、甲靠近時，乙收腳抽身，左手拿住甲的左腕，右手脫出握拳舉至體側（圖69）。

Movements: a.While A approaches, B withdraws her feet and retracts, holding A's left wrist with her left hand, and releases her being held right hand and clenches the fist and raises it to the side of her body (Fig. 69).

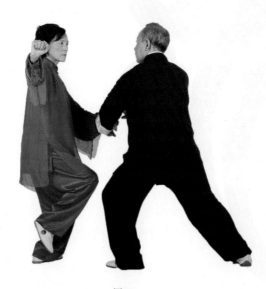

圖 69

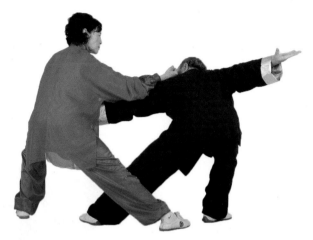

圖 70

2、隨之，右腳繞步至甲左腳後側，左腿屈弓成側弓步或偏馬步。同時左手外旋撐轉甲的左臂，右前臂外旋，滾壓甲的左肘，兩手合力成反關節撅臂。上體前傾，目視對（東北）方（圖70）。

b.Then, B circles her right foot to the rear of A's left foot, and bends her left leg to form a side bow stance or a biased horse stance; at the same time, rotates her left hand outwards to twist A's left arm, and rotates her right forearm outwards to roll and press A's left elbow, and exerts a joint force on both hands with bent joints together and pouts arm, her upper body leaning forwards, looking at the opponent (the Northeast) (Fig. 70).

要點：撅臂是反關節擒拿招法。一手採握對方腕關節，另一手前臂壓迫對方肘關節，兩手皆外旋（手心向上）合力，使對手陷於背動。定勢時，上體前傾助力，步幅可弓可馬。

Key Points: The pouting arm is an anti-joint tackling technique to grip the opponent's wrist joint with one hand and press the opponent's elbow joint with the forearm of the other hand. Both hands rotate outwards (palm upwards) and apply force together to make the opponent lose advantage in posture. When adopting fixed posture, leans the upper body forwards to assist, and can be a bow stance or s horse stance.

(三五) 甲翻身推按 (圖 71、72)
A-turn body and push-press(Fig.71,72)

招法: 翻腰提肘，弓步推按。

Tactics. turn the waist and raise the elbow, push in bow stance.

動作: 1、甲被撅臂時，迅速屈腿沈肩，重心右移。隨之上體左轉，翻腰屈臂提肘，左手反拿乙左腕向左捋帶；右手粘在乙左肘外側。頭隨體轉。目視左前（西南）方（圖71）。

Movements: a. While being pouting the arm, A quickly bends his legs and sinks his shoulders, and shifts his body weight to the right.

Then turns his upper body to the left, turns his waist and bends his arm, and lifts the elbow, with his left hand tackles B's left wrist and strokes it to the left; sticks his right hand to the outside of B's left elbow. his head moves with the tuning of his trunk, looking forwards (the Southwest)(Fig. 71).

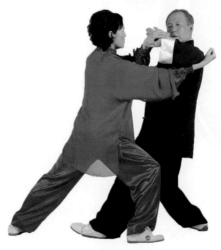

圖 71

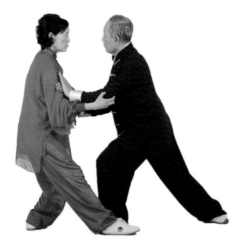

圖 72

2、上勢不停，甲轉腰向前（西），屈膝前弓成左弓步。同時，左手粘住乙左腕，右手粘住乙左肘，雙手向下向前推按。目視前方（圖72）。

b.Without stopping, A turns his waist forwards (the West), bends his knee to form a left bow stance; at the same time, sticks his left hand to B's left wrist and his right hand to B's left elbow, and push both hands downwards to the front, looking forwards(Fig. 72).

要點： 甲的解脫要及時。在未被壓死之前，迅速縮身屈臂，翻腰提肘，解脫背勢轉入反擊。

Key Points: A should dodge in time. He should quickly retract his body and bend his arms, turn his hips, lift his elbows before he is crushed, to turn a disadvantage into a counterattack

(三六) 乙双峰贯耳 (圖 73、74)
B-Strike Opponent's Ears With Both Fists(Fig.73,74)

招法: 兩手翻分格擋，繞步插襠，兩拳齊發，貫打對方頭部。

Tactics: circle step and thrust into the crotch, exert force on both fists at the same time, and hit the opponent's head.

動作: 1、甲按來時，乙坐腿含胸，右手繞至甲左腕內側，前臂外旋，手背著力，向右格開甲的左手；左手同時外旋，手背著力，向左格開甲的右手。右腳隨之屈膝提起。眼看右手（圖73）。

Movements:a.While A presses approaching, B sits on her leg and contract her chest, circles her right hand to the inner side of A's left wrist, rotates her forearm outwards, force point concentrating on the back of her hand, blocks away A's left hand to the right; then rotates her left hand outwards, force point concentrating on the back of her hand, blocks away A's the right hand to the left and bends her right knee to lift her right foot, looking at her right hand (Fig. 73).

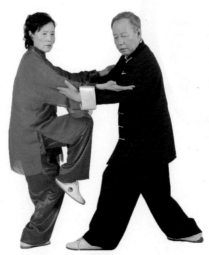

圖 73

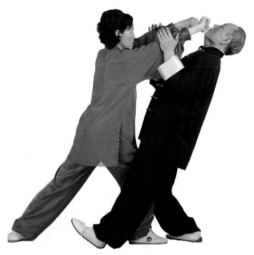

圖 74

　　2、上勢不停，乙右脚插落甲裆内，屈膝前弓成右弓步。同时两掌握拳齐发，经体侧划弧向前上方贯拳，擊打甲的左右额角太阳穴。力点在拳面。目视对（东）方（圖**74**）。

b.Without stopping, B thrusts her right foot into A's crotch, bends her knee to form a right bow stance; at the same time, strikes both fists together in an arc through the side of the body forwards and upwards to hit the left and right forehead temples of A, the force points concentrating on the face of the fists, looking at the opponent(the East) (Fig. 74).

　　要點：乙右掌插入甲腕内側後，與左掌同時外旋，向兩側分開甲的雙手，再繞步弓腿，兩拳齊發貫打甲頭部。此處的繞步為由外側向内，插入對方兩腿之間。

Key Points: After B thrusting her right palm into the inner side of A's wrist,rotates outwards with the left palm at the same time and separates A's two hands to both sides. Then circles step to form a bow stance, and punches on A's head from two sides with her two fists. Here circle step is from the outside to the inside and thrusting into between the opponent's legs.

(三七) 甲換步双按 (圖 75、76)
A-change steps and press with two hands(Fig.75,76)

招法: 退前腳，進後腳，雙手推按。

Tactics: step the front foot backwards, insert in with the rear foot, and push two hands

動作: 1、甲坐腿仰身，使乙拳落空（參見圖74）。隨之，左腳撤步至右腳後側，兩前臂內旋，兩掌內合，向下壓按乙的兩前臂。目視兩手（圖75）

Movements: a.A sits on his leg and leaned backwards to cause B's fist ineffective, then withdraws his left foot to the side and the rear of his right foot rotates his two forearms inwards, closes two palms together, and presses on B's two forearms downwards, looking at his two palms(Fig. 75)

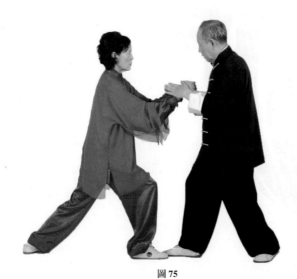

圖 75

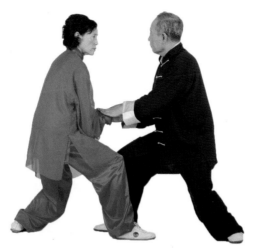

圖76

2、隨之，甲右腳前進半步，落在乙前腳內側，重心前移成小弓步。同時兩手向前推按乙的兩前臂。目視對（西）方（圖76）。

b.Then, A moves his right foot a half step forwards, dropping at the inner side of B's front foot, and shifts his bodyweight forwards to form a small bow stance; at the same time, with his two hands push and press B's forearms forwards, looking at the opponent(the West) (Fig. 76).

要點：撤步時兩手下按；進步時兩手前按，上下相隨。此時甲乙雙方步型皆半弓半馬，伺機待動。

Key Points: When withdrawing his step, presses both palms downwards; when stepping forwards, presses both palms forwards, so as upper limbs and lower limbs move in harmony. At this moment both A and B can adopt a half-bow stance or a half-horse stance, waiting for the opportunity to move.

（三八）乙化打冲捶（圖 77）
B-neutralize opponent's force point and Punch fist

招法： 轉腰順肩，左掤右冲拳。

Tactics: sit on the leg and turn waist, ward off left and punch right.

動作： 乙迅速轉腰、順肩，重心稍前移，上體稍左轉，成小弓步。同時右拳立拳冲打甲的前胸；左拳變掌，掌心向外，掤擋甲右臂。目視甲（東）方（圖77）。

Movements: B quickly turns the waist, extends her shoulders, shifts her bodyweight slightly forward, turns the upper body slightly to the left to forms a small bow stance; at the same time, punches her right fist with the thumb up forwards onto A's chest; unclench her left fist, palm facing outwards, and wards off A's right arm, looking at A (the East) (Fig.77).

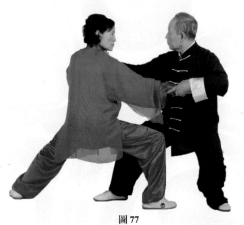

圖 77

要點： 先坐腿後引，再迅速轉腰順肩，冲拳攻擊。體現了太極拳隨屈就伸，化而後發的攻防技法。定勢時乙為小弓步，甲為虛步。

Key Points: The main point of this movement is to sit on the legs and drawback first, then quickly turn the waist and extend shoulders, punching and attacking. It embodies the offensive and defensive techniques of Taijiquan, which I stretch while opponent flex, and first neutralization, then attack. When B adopting the fixed posture, B forms a small bow stance and forms a small empty stance.

（三九）甲閃身推臂（圖 78）
A-elude(dodge) and push arm(Fig.78)

招法: 左閃右推，避正取斜。

Tactics: Flick left and push right, avoid the front conflict and apply the side attack.

動作: 甲迅速坐腿轉腰，閃開乙拳（參見圖77）。隨之再重心前移，上體右轉，左掌向右推按乙前臂。頭隨體轉，目視右前（西北）方（圖 78）。

Movements: A sits on his leg quickly, turns his waist to dodge B's fists(Fig. 77), Then shifts his bodyweight forwards, turns his upper body to the right, and pushes his left palm to the right and presses on B's forearms, his head moves with the tuning of his body, looking forwards to the right (the Northwest)(Fig.78).

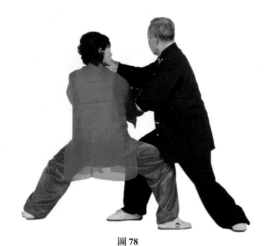

圖 78

要點: 本勢動作甲步法不動，全憑腰腿變化，避正取斜，完成攻防招法。定勢時，甲成小弓步，乙成偏馬步。

Key Points: This movement A's footwork is not changed and relies completely on shifting in waist and legs to accomplish the offensive and defensive techniques.

(四十) 乙挎肘剪臂 (圖79)
B-carry elbow and crosscut arm

招法: 左推右挎，交剪撅臂。

Tactics: push the right hip, cross-cut, and push the arm.

動作: 乙右臂被推時，順勢向左轉腰，左掌向外推剪甲的右腕；同時右前臂外旋，抄於甲右肘外側，拳心朝內，屈臂挎住甲的肘關節，與左手合力剪撅甲右臂。目視右拳（東北）方向（圖79）。

Movements: While the right arm being pushed, B turns her waist to the left with the trend and pushes his left palm outwards to cut the right wrist of A; at the same time, rotates her right forearm outwards, moves to the outside of A's right elbow, the heart of her fist facing inwards, and bends her arm to carry A's elbow joints, then pouts with her two hands together to cut the right arm of A, looking at her right fist (the Northeast) (Fig. 79).

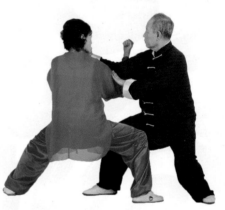

圖79

要點: 本勢與（三十四）乙滾肘撅臂同為反關節擒拿招法，但實施方法不同。本勢是左掌前推，右臂內挎，形成前後交剪撅臂。（三十四）動是左掌外旋撑轉，右臂外旋滾压，形成上下滾压撅臂。

Key Points: This movement is the anti-joint tackling technique which is the same as B's rolling elbow and pouting arm (movement 34), but the method to implement it is different. In this movement is to push the left palm forwards, carry the right arm from inside to form a back and forth cross-cut pouting pressure on the arm while in the movement(34), is to rotate the left palm outwards, and rotate the right arm to roll and press to form an up and down roll-press pouting pressure on the arm.

（四一）甲弓步推肘（圖 80）
A-bow stance and push elbow(Fig.80)

招法: 弓步推肘，解脫右臂。

Tactics: push the elbow in bow stance to free the right arm from being controlled

動作: 甲迅速屈腿沈肘，左手推按乙的右肘（參見图79）。同時屈膝前弓，重心前移成右弓步。目視前（西）方（圖80）。

Movements:A quickly bends his leg to sink his elbow, and pushes B's right elbow with his left hand (Fig. 79), at the same time, bends his knee forwards and shift his bodyweight forwards to form a right bow stance, looking forwards (the West)(Fig. 80)

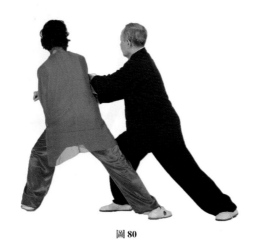

圖 80

要點: 根據對方姿勢高度，左手可以推乙右肘，也可以推按乙右肩或上臂。

Key points:According to the height of the opponent's posture, he can push his left hand on B's right elbow or B's right shoulder, or B's upper arm.

(四二) 乙返身撇捶 (圖 81)
B-turn back and smash the fist (81)

招法: 返身撇拳,擊打對方頭部。

Tactics: turn back and smash fist, hit the opponent's head

動作: 乙隨甲推肘之勢,重心左移,上體左轉(參見圖80)。隨之返身向右,右拳上舉,隨轉腰弓腿,右拳向前撇打甲的頭部;左掌掤住甲右腕不變。目視對(東)方(圖81)。

Movements: B follows the trend of A's elbow push, shifts her body weight to the left, and turns her upper body to the left (Fig. 80), then turns back to the right, raises her right fist upwards, rotates her waist, and arch her leg and move her right fist forwards to smash on A's head, with her left palm ward off A's right wrist remaining unchanged, looking at the opponent (the East)(Fig. 81).

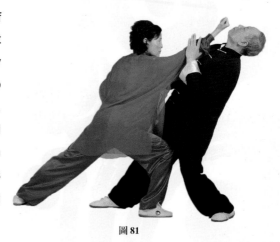

圖 81

要點: 撇拳是太極拳招法,又稱劈拳。拳自胸前上舉,經頭前時前臂翻擺轉拳心朝上,以拳背為力點劈打對方頭部。

Key Points: Piequan is a technique of Taijiquan, also known as a split fist(Piquan). Lifting the fist from in front of the chest upwards, the heart of the fist faces downwards. When it is turned to in front of the head, flips the forearm to the heart of the fist upwards, and smashes it to the opponent's head with force point concentrating on the back of the fist.

（四三）甲轉腰化按（圖 82)

A-turn waist and neutralize and press(Fig.82)

招法：坐腿轉腰，向右化按。

Tactics: sit on leg and turn waist, rotate to right to neutralize, and press.

動作：乙右拳劈來時，甲坐腿閃身，上體後仰（參見圖81）。隨之向右轉腰，左手移至乙右腕處向右化按，使乙拳落空。頭隨體轉，眼看左（西北）手（圖82）。

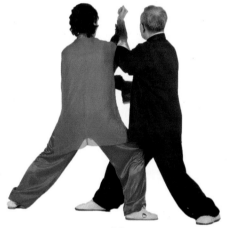

圖 82

Movements： While B's right fist approaching, A sits back on his leg and leans his upper body backwards, then turns his waist to the right, moves his left hand to B's right wrist neutralize and press it to in the front of B's chest, causing B's fist ineffective. his head moves with the tuning of his body, looking at his left hand(the Northwest)(Fig-82).

要點：閃身轉體與左掌化按要協調配合，周身形成一個整體。

Key Points: The dodging body, turning the body should be well-coordinated with the neutralization and press palm. The whole body is to act in harmony as one.

(四四) 乙化打叠肘 (圖83、84)

B-neutralize opponent's force point and fold elbow(Fig.83,84)

招法: 轉腰屈肘，叠臂化打。

Tactics: Turn the waist and bend the elbow, neutralize,fold arms and strike

動作: 1、乙乘甲化按之勢，坐腿收腹，向右轉腰，右臂屈肘叠臂收至腰間，隨之前臂內旋，肘尖上提。目視右肘（圖83）。

Movements: a.Makes use of A's pressing force, B sits back on her legs and pulls in her abdomen, turns her waist to the right, flexes her elbow and folds her arm to the waist, then rotates her front arm inwards, and lifts the tip of her elbow, looking at her right elbow (Fig. 83).

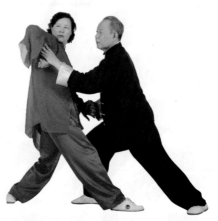

圖 83

2、上勢不停，乙迅速弓腿轉腰成右弓步。同時上體前傾，以右肘關節外側為力點，向前屈肘叠臂打擊甲的胸部；左手仍粘附甲腕不變。目視對（東）方（圖84）。

b. without stopping, B quickly bows her leg and turns her waist into a bow stance; at the same time, leans her upper body forwards, using the outside of the right elbow joint as the point of force, bends her elbow forwards and folds the arm to strikes A's chest, her left hand still sticking to A'wrist unchanged, looking at the opponent(the East) (Fig. 84).

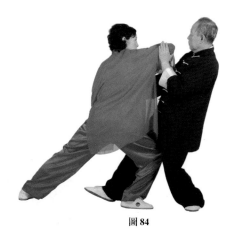

圖 84

要點：此勢先坐腿轉腰，向右後引化。隨之轉腰弓腿，上體前压，屈肘疊臂反擊。力點在肘關節外側。發力源自腰腿，合於周身，氣沈丹田，內外完整一體。自（三八）動至本動，甲乙雙方原地不動，沒有步法，全在重心移動和腰的旋轉完成攻防，體現太極拳隨屈就伸，化而後發的技法。

Key points: In this movement, first, sit her leg backwards and turn her waist, then turns to the right and backwards to neutralize. Then turns her waist and arches her legs, presses her upper body forwards, and bends her elbows, folded her arms to counterattack. The point of force is concentrating on the outside of the elbow joints. The force is originated from the waist and legs, gathering in the whole body, lowers qi into dantian acupoint, and the inside and outside are integrated as one. From movement 38 to this movement, both A and B haven't moved their steps, namely without any footwork is applied, all attacks and defenses are completed by shifting their bodyweight and the rotation of the waist, which embodies the offensive and defensive techniques of Taijiquan, which I stretch while opponent flex, and first neutralization, then attack

（四五）甲採手橫挒（圖 85、86)
A-grap hand and pull horizontally(Fig.85,86)

招法: 收腳下採，上步橫挒。

Tactics: close foot and grab hand, step forwards and press horizontally.

動作: 1、乙右肘擊來時，甲坐腿閃身，使乙落空（參見圖84）。隨之右腳收至左腳內側，腳前掌著地，屈膝下蹲，上體右轉。右手內合下落，採住乙右腕；左手粘在乙右肘外側，助勢下採。眼註視右手（圖85）。

Movements: a.While B's right punch approaching, A sits backwards on his legs to dodge, causing B's attack ineffective (Fig. 84), then closes his right foot to the inside of his left foot, the sole of his forefoot on the ground, bending his knee to squat down, and turns his upper body to the right, closes his right hand inwards and grabs B's right wrist, sticks his left hand to the outside of B's right elbow to assist the downwards pressing, looking at his right hand(Fig. 85).

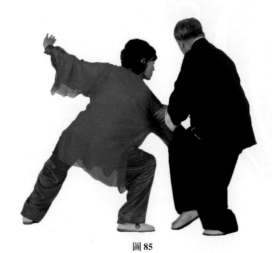

圖 85

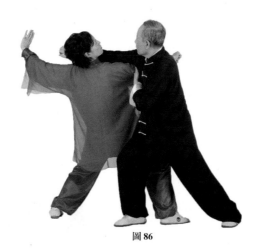

圖 86

2、隨之，右腳向前上步，落在乙右腳後方，屈膝前弓。同時上體前傾左轉，右臂內旋前舉，拳心朝右橫置乙胸前，反臂握拳，向左橫捌；左手仍附在乙右肘外側，助力扭轉。目視前（西）方（圖86）

b.Then, steps his right foot forwards, at the rear of B's right leg, bends his knee, and bow forwards; at the same time, leans his upper body forwards and turns to the left, rotates his right arm inwards, and raise forwards to the in front of B's chest, clenches his right fist with back arm, the heart of his fist facing to the right and hits horizontally to the left and his left hand is still stuck on the outer side of B's right elbow to assist twisting, looking forwards (the West) (Fig. 86)

要點：橫捌時，甲右臂向左橫捌，左掌向右助力。使乙向左扭轉後倒。

Key Points: While hitting horizontally, the right arm of A exerts force forwards to the left, and the left palm is to press backwards to the right rear to assist which makes B to turn to the left, then fall.

(四六) 乙換步撅臂 (圖 87、88、89)
B-change steps and pouting arm(Fig.87-89)

招法: 左右換步，滾肘撅臂。

Tactics: change feet left and right, rolling elbow, and pout arms.

動作: 1、甲靠近時，乙速撤右步，脫身抽手，右臂上舉內旋，右手反握（掌心向外，虎口朝下）甲的右腕（圖87）。

Movements: a.While A approaching, B quickly withdraws her right foot and hand to dodge, and raises her right arm, and rotates it inwards, grabbing A's right wrist with her backhand (palm facing outwards, tiger's mouth facing downwards) (Figure 87).

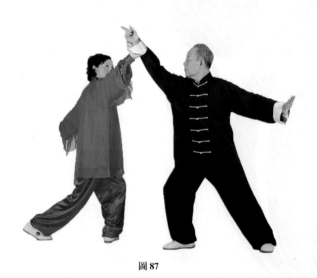

圖 87

2、隨之，乙左腳上步落在甲右腿後側，右腿屈弓成側弓步或偏馬步。同時右手外旋，撐轉甲的右臂；左手握拳，左前臂外旋滾圧甲的左肘，兩手合力，反關節撅拿甲的右臂。上體前傾，目視對（東南）方（圖88、89）。

b.Then, B steps her left foot forwards and drops at the rear of A's right leg, bend her right leg to a side bow stance or a biased horse stance; at the same time, rotates her right hand outwards, twisting A's the right arm, clenches her left fist and rotates her left forearm outwards, rolling a pressing A's left elbow, and exerts a joint force on both hands with bent joints together and pouts her shoulder, her upper body leaning forwards, looking at the opponent(the Southeast)(Fig. 88 and 89).

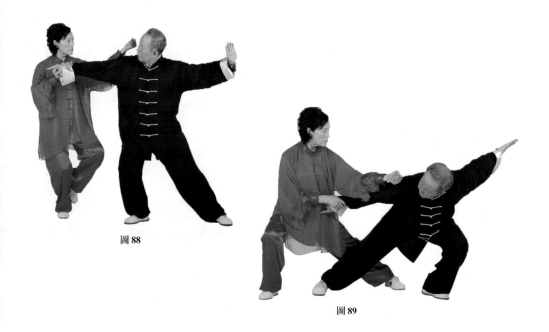

圖 88

圖 89

要點： 撅臂是反關節擒拿招法。一手採握對方腕關節，另一手前臂壓迫對方肘關節，兩手皆外旋合力，使對手陷於背動。定勢時，上體前傾助力，步幅可弓可馬。

Key Points: The pouting arm is an anti-joint tackling technique to grip the opponent's wrist joint with one hand and press the opponent's elbow joint with the forearm of the other hand. Both hands rotate outwards (palm upwards) and apply force together to make the opponent lose advantage in posture. When adopting fixed posture, leans the upper body forwards to assist, and can be a bow stance or a horse stance.

第三段　Section 3

(四七) 甲右貫拳伏虎 (圖 90、91)
A-sweep right side and punch and tame the tiger(Fig.90,91)

招法：摘手繞步，貫拳擊頭。

Tactics: pick up hand and circle step to behind the opponent, punch through the head.

動作： 1、乙靠近時，甲左手反手（掌心向外，虎口朝下）摘拿乙左腕；右臂外旋，右拳掙脫乙右手收到腰間。隨之提起右腳（圖90）。

Movements: a.While B approaching, A takes off B's left wrist right with his right backhand (palm facing outwards, tiger's mouth facing downwards), then lifts his right foot, rotates his right arm outwards, breaks his right fist away from B's right hand, moves it to his waist (Fig. 90).

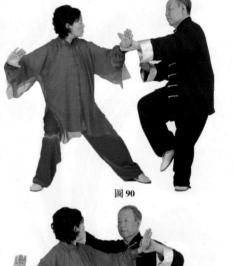

圖 90

2、上勢不停，甲右腳繞步落在乙左腳後側，屈膝前弓成右弓步。同時右拳內旋外擺，向前貫打乙頭部，力點在拳面，目視對（西南）方（圖91）。

b.Without stopping, A circles a step with his right foot and drops at the side and rear of B's left foot, and bends his knee forwards to form a right bow stance; rotates his right fist inwards and swings outwards to strike forwards on B's head, the point of force concentrating on the face of his fist, looking to the opponent(the Southwest) (Fig.91).

圖 91

要點: 右拳脫手內抽時，屈臂外旋，重心左移，上體右轉；右拳向前貫打時，展臂內旋，重心右移，上體左轉。

Key points:When the right fist is released, bends the arm and rotates outwards, shifts the body weight to the left, and turns the upper body to the right. When the right fist is struck forwards, extends the arm and shifts the body weight to the right, and turns the upper body to the left.

(四八) 乙轉身大捋 (圖 92、93、94)
B-turn body and large deflection (Fig.92-94)

招法: 繞行步轉身左捋。

Tactics: circle step and deflect to the left with turning of the body.

動作: 1、甲拳擊來時，乙坐腿閃身，左腳前移半步，腳尖外擺，屈膝前弓，向左轉腰。同時左手內旋翻腕，反手採拿甲左腕向左牽捋。頭隨體轉，目視對（西南）方（圖92）。

Movements:a. While A's fist approaching, B sits back on her leg to dodge, moves her left foot a half step forwards, toes pointing outwards, bends her knees to form a bow stance, and turns her waist to the left; at the same time, turns her wrist with the inward rotation of her left hand, with her backhand grabs A's left wrist with the backhand and drags to the left, her head turns with the rotation of her waist, looking at the opponent (Southwest) (Fig.92).

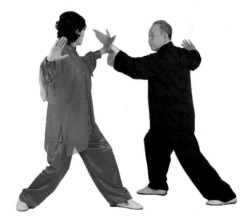

圖 92

2、上動不停，乙右腳隨即沿弧線向左前方繞行一大步，腳尖內扣。身體隨之向左轉，左手牽甲左腕繼續左捋，右前臂外旋滾肘，沾附甲左臂外側助力左捋。此時甲左腳隨之沿弧線向前一大步，腳尖外擺，屈膝前弓，上體左轉。二人目光對視（圖93）。

d.b. Without stopping, B moves her right foot in a big s-step forwards to the left, toes buckled inwards, then turns her body to the left, with her left hand grabbing A's left wrist and continuing to deflect to the left, rotates her right forearm outwards and rolls her elbow to stick to the outer side of A's left arm assisting the left deflection, at this time, A moves his left foot a big s-step forwards along the line of the arc, toes swinging outwards, bends his knee to bow forwards, and turns his upper body to the left, both A and B looking at each other (Fig.93).

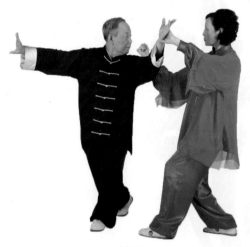

圖 93

3、繼上勢，乙左腳向身後（西）退一大步，上體左轉，右腿屈弓成右弓步。兩手向左捋勢不變。此時甲隨之沿弧線向前再上一大步，腳尖內扣，屈膝前弓。目光對視，此時甲乙二人位置再次左右（東西）調換（圖94）。

c.Continuously, B steps a big step backwards (the West) with her left foot, turns her upper body to the left, and bends her right leg to form a right bow stance, keeping left deflection with both hands unchanged; at this time, A follows B to move a big step

forwards along the line of the arc again, his toes buckling inwards, and bends his knee to bow forwards, both A and B looking at each other, and at this moment the positions of A and B are reversed(Fig.94).

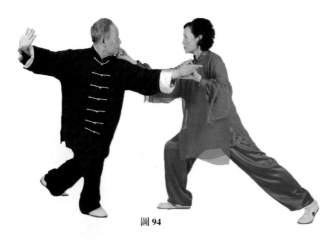

圖 94

要點: 甲乙二人沿弧線繞上步，乙捋甲隨。乙經過左擺、右扣、左退三步，甲經過左擺、右扣兩步。位置對調互換。

Key Points: A and B step up along the line of the arc, while B deflecting and A following. B makes three steps, namely left swing, right buckling, and left retreating. A walks two steps,namely left swinging and right buckling. Thus the positions of A and B have been swapped.

(四九) 甲上步左靠 (圖 95)
A-step forward and squeeze to the left(Fig.95)

招法: 上步插襠，左肩擠靠。

Tactics: step up and insert the crotch, press and squeeze with the left shoulder.

動作: 1、甲順乙捋勢沿弧線繞行兩步。參考上動（圖93、94）。

Movements: a.Following the momentum of B's deflection, A walks two steps along the line of the arc, refer to the above movement(Fig.93,94)

2、甲順勢左腳經乙右腳內側，向前上步插入乙襠內。同時右掌附按在左上臂內側助力，屈膝前弓，用左臂和左肩擠靠對方。目視對（東）方（圖95）。

b.Steps his left foot forwards passing through the inside of B's right foot, and inserts into B's crotch; at the same time, touches his right palm on the inside of his left upper arm, bends his knee and bow forwards, and press and squeeze against the opponent with his left arm and left shoulder, looking to the opponent(the East)(Fig.95).

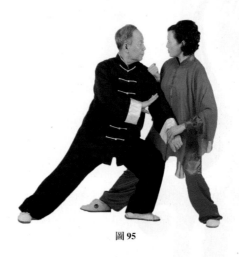

圖 95

要點：甲上步速度、步幅、落點皆要隨乙行步捋勢而定，隨曲就伸，不丟不頂。定勢步型可弓步可馬步。

Key Points: The stepping speed, stride length, and dropping point of A should be adapted to B's walking steps and the force of B's deflection. The rule here is to follow that I stretch while opponent flexes and neither separate from nor make forcible contact with the opponent. While adopting fixed posture,either bow stance or horse stance can be applied.

（五十）乙弓步回擠 （圖 96）
B-bow stance and press back (Fig.96)

招法： 轉腰弓步回擠。

Tactics: turn the waist and push back in bow stance

動作： 乘甲前靠之勢，乙坐腿縮身（參見圖95），上體右轉，右拳變掌，掌心向內，前臂外側粘附甲左臂，左手掌心朝前，附在右前臂內側，屈膝前弓回擠對方。目視前（西）方（圖96）。

Movements: Makes use of A's forward-leaning force, B sits back on her leg and retracts her body (Fig. 95), turns her upper body to the right, unclenches her right fist, palm facing inwards, sticks the outside of her right forearm to A' left arm, with her left palm facing forwards attaches to the inside of her right forearm, bend her knee and push forwards in bow stance the opponent, looking forwards(the West) (Fig. 96).

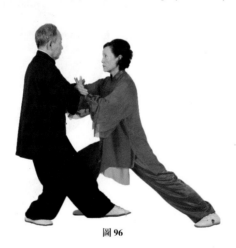

圖 96

要點： 坐腿轉腰引化和弓步回擠，皆要上下配合，周身一體，形成合力。

Key Points: Sitting back on the leg and turning the waist to neutralize the attack, and counter-push in a bow stance, both upper body and lower body should well cooperate. The whole body should act like one to form a joint force.

(五一) 甲換步分靠（圖 97、98）
A-change steps and separate and squeeze(Fig.97,98)

招法: 撤步分手，上步前靠。

Tactics: Withdraw the step and separate hands, move forwards squeeze against forwards.

動作: 1、乘乙前擠之勢，甲坐腿縮身，左腳撤至右腳內側，提起右腳。同時兩手內旋分開，掌心向外，拿住乙的兩腕，向左右撐開乙的兩臂（圖97）。

Movements: a.Makes use of B's forward-leaning force, A sits back on his leg and retracts his body (Fig. 96), and lifts his left foot; at the same time, closes both hands first, then separates them, ward off, then props up, with palms facing outwards grabs B's two wrists, and spreads B's arms to the left and right respectively (Fig. 97).

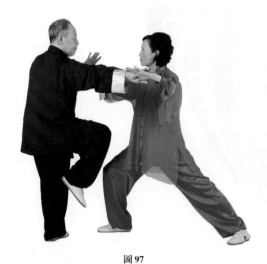

圖 97

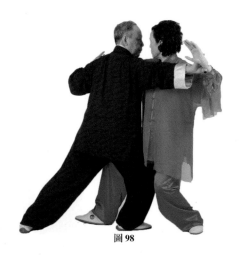

圖 98

2、上勢不停，甲右腳隨即上步插入乙襠內，屈膝前弓成右弓步。同時用右肩向前擠靠乙的胸部。目視對方（圖98）。

b.Without stopping, A drops his left foot at the inside of his right foot, then immediately inserts his right foot into B's crotch, bending the knee and arching forwards to form a right bow stance, at the same time, with his right shoulder hitting B's forwards to B's chest, looking at the opponent(Fig. 98).

要點：換步指兩腳位置前後交換。撤步和上步的落點，皆要視對方距離而定，做到不丟不過，攻防合理，有利招法的運用。

Key Points: Changing steps means exchanging the position of the front foot and the rear foot. The dropping points of both the withdrawal step and the forwarding step depend on the distance to the opponent, to avoid neither empty nor too excessive, and ensure that the offensive and defensive are reasonable, which can help apply the tactics.

（五二）乙換步穿靠（圖 99、100）

B-change steps and Piercing the palm
and squeeze(Fig.99,100)

招法：換步穿掌，弓步左靠。

Tactics: change steps and spiere palm, squeeze against to the left in bow stance.

動作： 1、當甲靠近時，乙速重心後移，撤右腳，提左腳，上體右轉，使甲落空。同時左掌外旋，繞至甲右腕內側；右掌內旋，脫開甲左手，擺至身後。目視對（西）方（圖99）。

Movements: a.While A approaching, B immediately shifts her bodyweight backwards (Fig. 98), withdraws her right foot, lifts her left foot, and turns her upper body to the right to cause A's attack ineffective; at the same time, rotates her left palm outwards and circles to the inside of A'right wrist, rotates her right palm inwards to get rid off A's left hand and moves to behind her body, looking at the opponent(the West) (Fig. 99).

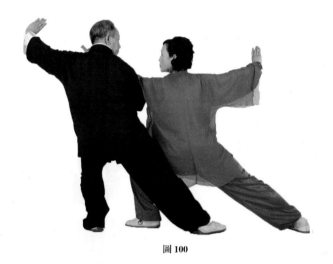

圖 100

2、隨之，乙左腳前落插入甲襠內，屈膝前弓成左弓步。同時用左肩擠靠甲右肩，上體前傾，胸向西北，目視前（西）方（圖100）。

b.Then, B takes a step forwards with her left foot and inserts into A's crotch, bends her knee to form a left bow stance; at the same time, with her left shoulder hits on A's right shoulder, leans her upper body forwards, the chest facing to the northwest, looking forwards (the West)(Fig 100).

要點：把握好換步的時機和落點，做到攻防合理，配合嚴密，不丟不頂。

Key points:Here is to grasp the timing and point of changing steps, apply reasonable offense and defense, cooperate closely, and neither separate from nor make forcible contact with the opponent.

(五三) 甲摘手頂肘 (圖 101)
A-pick up hand and jab elbow(Fig.101)

招法: 左手摘拿，馬步右頂肘。

Tactics: pick up with the left hand, push the elbow on the right in a horse

動作: 乙靠近時，甲速屈腿向左閃身（參見圖100），左手從右前臂下穿出，反手（手心向外，虎口朝下）摘拿牽引乙左腕，使其落空。隨之重心右移，屈腿蹲身成馬步。右臂摺屈，用肘尖頂撞乙左肋。目視右（東北）側（圖101）。

Movements: When B approaching, A immediately bends his leg and dodge to the left (Fig. 100), pierces his left hand through under his right forearm, and with his backhand (palm facing outwards, tiger mouth facing downwards) holds B's left wrist, then shifts his body weight to the right, bending his legs and squatting down into a horse stance, bends his right arm and hits B's rib with the tip of his folding elbow, looking to the right (the Northeast) (Fig. 101).

圖 101

要點: 太極拳招法術語，向上擒拿對方手腕叫摘手；向下擒拿對方叫採手。定勢時步型屈腿下蹲成馬步或偏馬步。。

Key Points: In Tai Chi techniques terms, grabbing the opponent's wrist upwards is called zhaishou; grabbing the opponent's wrist outwards is called Banshou, and grabbing the opponent's hand downwards is called Caishou. While adopting fixed posture, the stance by squatting down can be a bow stance or a biased horse stance.

(五四) 乙金雞獨立 (圖 102、103、104)
B-golden rooster Stands on one leg(Fig.102-104)

招法: 右挑左摟，跟步提膝前頂。

Tactics: right pick up and left brush, free step, lift the knee and push forwards.

動作: 1、甲頂來時，乙左腳速後撤半步，腳尖外撤，上體左轉。同時右手下落經左臂下穿出，向上挑開甲的左手；左手解脫後向下摟開甲的右手。目視對方（圖102）。

Movements: a.While A's attack approaching, B retreats her left foot quickly half a step, swinging her toes outwards, and turns her upper body to the left, at the same time, moves her right hand downwards and pierces through under the left arm, then picks away A's left hand upwards, after her left hand is released, blocks downwards A's right, looking at the opponent (Fig. 102).

圖 102

2、隨之，甲右腳跟步至左腳後側，左腿屈膝上提，用膝關節向前頂撞對方小腹。目視對（西南）方（圖103、104）。

2. Then, follow the right foot to the back of the left foot, bend the left leg and lift it up, and use the knee joint to hit the opponent's abdomen forward. Visually to the Southwest (Fig. 103, 104).

圖 103　　　　　　　　　　　圖 104

要點：本勢乙右手可以上挑，掌心向內。也可以旋臂反手摘拿，掌心向外，握住甲的左腕。步法移動為前腳後撤半步，後腳跟進半步，身體左轉，逼近對方，提膝前頂。

Key points:In this movement B can pick up with the right hand, palm facing inwards, and can also rotate the arm and tackle with her backhand, palm facing outwards, holding A's left wrist. The shifting of footwork is half a step backwards with the front foot, half a step forwards with the hindfoot, turning her body to the left to approach the opponent, and lift the knee and hit forwards.

（五五）甲退步合按（圖105）
A-step backwards and press hands inwards(Fig.105)

招法: 退步閃身，雙手合按。

Tactics: step backwards to dodge the body, close, and press.

動作: 甲坐腿收腹，右腳後退一步。隨之兩手旋臂內合，按住乙的兩腕。目視對（東北）方（圖105）。

Movements: A sits on his leg and pulls in his abdomen, and steps his right foot a step backwards, then rotates his two arms and close inwards to press on B's two wrists downwards, looking at the opponent(the Northeast)(Fig. 105）。

圖 105

要點: 甲兩手內合之前，要先旋臂翻腕，脫開乙的兩手控製，變被動為我順人背之勢。

Key Points: Before A's hands are closed inwards, he should first rotate his arms and turns his wrists to get rid of the control of B's two hands to turn inferior posture into advantage posture.

（五六）乙十字蹬腳（圖 106）
B-cross kick(Fig.106)

招法： 兩手分撐，左腳前蹬。

Tactics: separated cross hands and kick left foot forwards.

動作： 乙兩臂微沈，兩手內旋，掌心向外，向兩側分開甲的雙手。同時左腿伸直，腳底著力，蹬踹甲腹部。目視對（西南）方（圖106）。

Movements: B sinks two arms slightly, rotated both hands inwards, palms facing outwards, and with her two hands to separate A's hands to both sides respectively; at the same time, straightens her left leg and kicks on A's abdomen, the force point concentrating on the sole of her left foot, looking at the opponent(the Southwest) (Fig. 106).

要點： 太極拳招法，腳尖著力前踢叫分腳；腳底著力蹬踹叫蹬腳。

Key Points: Taijiquan technique: kicking forwards with force point at toes is called separating foot, kicking with force point at the sole is called kicking foot.

圖 106

(五七) 甲纏臂左靠 (圖 107、108、109)
A-twining arm and squeeze to the left(Fig.107-109)

招法: 繞步右搂,進步左纏,弓步肩靠。

Tactics: step up and twins to the right, step up and twins to the left, squeeze against on the shoulder in a bow stance.

動作: 1、甲坐腿閃身(參見圖106)。右手纏繞至乙左臂內側,向下向右搂開乙左腿。同時右腳向左前方繞上步,腳尖外擺,上體右轉,重心前移。頭隨體轉(圖107)。

Movements:a.A sits on his leg to dodge (Fig. 106). Twins his right hand to the inside of B's left arm, and brush away B's left leg downward; at the same time, steps his right foot forwards to the left, swinging the toes outwards, turning the upper body to the right, and shifting his body weight forwards, his head moving with the tuning of his body, (Fig. 107).

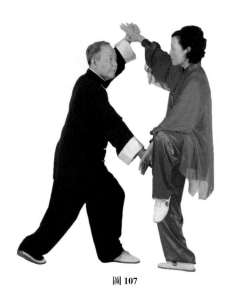

圖 107

2、上勢不停，甲左腳再上步，落至乙右腳後側。左手粘附乙右腕向右、向下纏繞，左臂斜置體前，擠壓乙的右臂（圖108）。

b.Without stopping, A steps his left foot forward again and drops at the side of B's right foot rear. Sticks his right hand to B's right wrist, and twin downwards to the right, his left arm is tilting in front of his body and presses B's right arm (Fig. 108).

3、甲屈膝前弓，重心前移成左弓步。右手附於左肘內側助力，用左肩擠靠乙右肩。目視對（東南）方（圖109）。

c.Attaching his right hand to the inside of his left elbow, bends his knee forwards, and shifts his body weight forwards to form a left bow stance, presses his left shoulder against B's right shoulder, looking at the opponent (the Southeast)(Fig. 109).

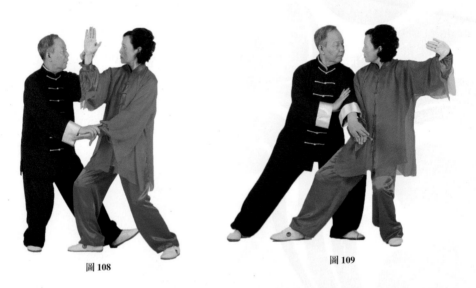

圖 108　　　　　　　　圖 109

　　要點：參見（三三）動上步纏靠。唯本動步法是進步，太極拳術語，兩腳連續上步叫進步。（三三）動是前腳活步移動，後腳上步。

Key Points: see movement(33) which footwork is to make a free moving step of the front foot whereas the footwork in this movement is a forwarding step. In Taijiquan terms, move two steps forwards continuously is called forwarding steps. In Movement(33)is to make the front foot moving freely and the back foot follow up.

（五八）乙繞步撅臂（圖 110、111）
B-circle step and pouting with arm(Fig.110,111)

招法： 拿腕繞步，滾肘撅臂。

Tactics: Grab wrist, roll elbow and pout arm.

動作： 1、甲靠近時，乙坐腿閃身，重心後移，右腳提起，使甲落空。同時，左手拿住甲的左腕，右手脫出握拳，前臂粘住甲的左肘外側（圖110）。

Movements： a.While A approaching, B sits on her leg to dodge and shifts her bodyweight backwards (Fig.109), then lifts her right foot to cause A's attack ineffective; at the same time, grabs A's left wrist with her left hand, after making her right hand free, B clenches her right fist, and with her forearm sticks to the outer side of A's left elbow(Fig. 110).

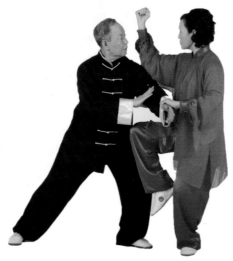

圖 110

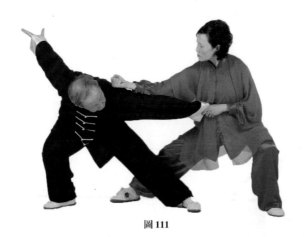

圖 111

2、隨之，右腳繞落在甲左腳後側，左腿屈弓成側弓步或偏馬步。同時左手外旋擰轉甲的左臂；右前臂外旋，滾壓甲的左肘，兩手合力成反關節撅臂。上體前傾，目視對（西南）方（圖111）。

b.Then, B circles her right foot and drops at the side of the left foot rear, and bends her left leg to form a side bow stance a biased horse stance; at the same time, rotates her left arm outwards to twist A's left arm, rotates her right forearm outwards, rolling and pressing on A's left elbow, and exerts a force on her two hands together and pouts opponent's in bent joints, leaning her upper body forwards,looking at the opponent(the Southwest)(Fig. 111).

要點： 肘是太極拳八法之一，泛指用肘關節或前臂的攻防招法。頂肘是用肘尖頂撞對手。滾肘是用前臂外旋牽製對手，力點在前臂外側。本勢滾肘是壓製對方的肘關節。其它要點同（三四）動。

Key points:The elbow technique is one of the eight techniques of Taijiquan, which is an attacking tactic with the elbow joints or forearm. The jabing elbow is to hit the opponent with the tip of the elbow. The rolling elbow is to rotate the forearm outwards to control the opponent,the point of force concentrating on the outside of the forearm. The rolling elbow in this movement is to suppress the opponent's elbow joint (the East). The other points are the same as the movement(34).

(五九) 甲右分脚 (圖 112、113、114)
A-separate legs and kick right(Fig.112,113,114)

招法: 左右掤架，右脚踢肋。

Tactics:ward off right,kick on rib with right foot.

動作: 1、針對乙撅臂之勢，甲迅速翻腰提肘，左臂掤架乙前臂。隨之左脚撤至右脚內側，上體左轉，右手上挑，掤架乙右腕。目視對（東）方（圖112、113）

Movements: a.In response to B's pouting, A quickly rolls over his waist and raises his elbow, and with his left arm ward off B's forearm, then withdraws his left foot to the inside of his right foot, turns the upper body to the left, pick up the right hand, and draws his right hand upwards to fend off B's right, looking at the opponent(the East)(Fig. 112, 113)

圖 112

圖 113

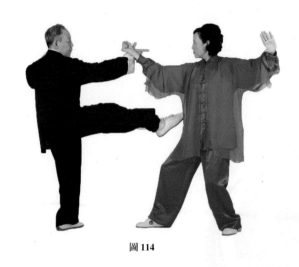

圖 114

2、上勢不停，甲擺踢右腳，用腳尖踢向乙的右肋。目視對方，此時甲面向東，乙面向西（圖114）。

b.without stopping, A swings his right foot and kicks B's right rib with the toes of his foot, looking at the opponent, now A is facing the East, and B is facing the West (Fig. 114).

要點：甲的解脫要及時。在未被壓死之前，迅速縮身屈臂，翻腰提肘，上體左轉，解脫背勢。

Key Points: A should dodge in time. Before being crushed, he should quickly retract his body and bend his arms and turn over his waist and raise his elbow, and turn his upper body to the left to reverse his disadvantage.

（六十）乙右摟膝（圖 115）
B-brush knee -left

招法：左上架，右下摟。

Tactics: block high left, brush downwards right.

動作：甲左腳踢來時，乙重心後移，左掌從右前臂下穿出，內旋翻掌架開甲的右手；右手隨之下落，向外摟開甲的右小腿。目視對（西）方（圖114、115）

Movements: While A's left kick approaching, B shifts her bodyweight backwards, pierces out her left palm through under his right forearm, and rotates her palm inwards and blocks off A's right hand; drops her right hand along with it, and brushes away A's right calf outwards, looking at the opponent(the West)(Fig.115)

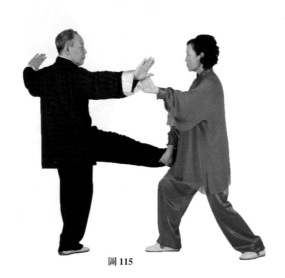

圖 115

要點：左架右摟時，掌心皆內旋朝外。

Key points: While blocking left and brush right, the palms are all rotated inwards and facing outwards.

(六一) 甲左分脚 (圖 116、117)
A-separate legs and kick left(Fig.116,117)

招法: 左手掤架，左腳踢肋。

Tactics: ward off left and left kick rib

動作: 1、甲右腳迅速收回落於左腳內銂，腳尖外撇。隨之重心右移，上體右轉，左手經右前臂下穿出，向上掤架乙左腕。目視前（東）方（圖116）。

Movements: a.A quickly retracts his right foot and drops at the inner side of the left foot, and the toes pointing outwards then shifts his bodyweight to the right, turns his upper body to the right, pierces out his left hand through under the right forearm, and wards off B's left wrist upwards, looking forwards (the East)(Fig. 116).

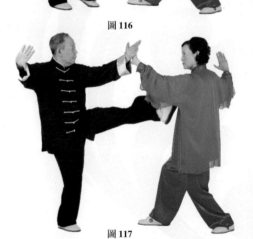

圖 116

2、上勢不停，甲擺踢左腳，左腳尖踢向乙的左肋。目視對（東）方（圖117）。

b. Without stopping, A swings his left foot and with the toes kicks B's left rib, looking at the opponent(the East)(Fig. 117).

圖 117

要點: 左手掤架時掌心向右，力點在腕關節外側。

Key points: While warding off with his left hand, the palm is facing to the right, and the point of force is on the outside of the wrist joints.

（六二）乙左摟膝 （圖118）
B-brush knee - left

招法: 換步右上架，左下摟。

Tactics: block high right, brush downwards left.

動作: 甲左腳踢來時，乙左腳收攏半步，右腳後退一步成左弓步。同時上體左轉，右手從甲左腕下穿過，翻腕架開甲左腕；左手隨之下落，向外摟開甲的左小腿。目視對（西）方（圖118）。

Movements: While A's left kick approaching, B gathers his left foot a half step forwards, and moves her right foot a step backwards to form a left bow stance; at the same time, turns her upper body to the left, pierces out her right hand under A's left arm, and rotates her wrist to block away A's left wrist, then drops her left hand, and brushes away A's left calf outwards, looking at the opponent(the West) (Fig. 117).

圖 118

要點: 右手上架和左手下摟，皆前臂內旋，掌心向外。與左右腳換步，協調配合，同時完成。

Key Points: While blocking high right and brush down left, both forearms are rotated inwards and palms are facing outwards. This should be well-coordinated and cooperated with the change steps between the left and the right foot, and complete at the same time.

(六三) 甲採手右靠 (圖 119、120、121)
A-pull hand and squeeze to the right(Fig.119-120)

招法: 右手下採，右肩前靠。

Tactics: press down with the right hand and squeeze forwards with the right shoulder.

圖 119

動作: 1、甲收回左腳，落在右腳內側。同時上體左轉，右手自後向前，從乙右腕下穿出；左手脫出後擺至體側。目視右手（圖119）。

Movements: a.A retracts his left foot and drops at the inside of his right foot; at the same time, turns his upper body to the left, pierces his right hand from back to front, and through under B's right wrist, after making his left hand free and swing it to the side of the body, looking at his right hand (Fig. 119).

2、隨之，上體右轉，右臂內旋，反手（掌心向右，虎口朝下）抄拿乙右腕向右側下採。同時右腳屈膝前提。目視右手（圖120）。

b.Then, A turns his upper body to the right, rotates his right arm inwards, and with his backhand (palm facing to the right, tiger's mouth facing down), grabs B's right wrist and pulls downwards to the right; at the same time, bends his right knee and lifts it forwards, looking at his right hand (Fig.120).

圖 120

3、右腳前落成右弓步，上體左轉，以右肩擠靠乙的右肩；左手平舉於身體側後。目視前方（圖121）。

c. A drops his front foot to form a right bow stance and turns his upper body to the left, and with his right shoulder squeeze against B's right shoulder, raising his left hand flatly at the side of his body, looking forwards (Fig. 121).

圖 121

要點：抄拿是武術術語。手自下向上伸舉，內旋翻腕擒拿對手為抄拿。

Key point: Chao Na is the term of martial art. The palm is stretched from the bottom upwards and rotated wrist inwards to grab the opponent. It is called tackling.

(六四) 乙採手回靠 (圖 122、123、124)
B-pull and szueeze back(Fig.122-124)

招法: 翻手下採，弓步回靠。

Tactics. Flip hand and press downwards, bow stance, and szueeze back.

動作: 1、當甲靠近時，乙順勢坐腿轉腰，使甲落空（參見圖121）。隨之左腳後撤，右臂內旋前送上舉，右手反手翻拿甲右腕至頭前。目視右手（圖122）。

Movements: a.While A approaching, with the trend B sits on her leg and turns her waist to cause A's attack ineffective(Fig.121), then withdraws her left foot; at the same time, rotates her right arm inwards and raises forwards and upwards, and with her the right backhand tackles A's right wrist to the front of her head, looking at her right hand (Fig. 122).

圖 122

圖 123

圖 124

2、隨之，右腳向前上一大步，屈膝前弓成右弓步。同時右手下採甲右腕至體側下方，右肩向前擠靠甲右肩；左手舉在身體側後。目視前方（圖123、124）。

b.Then, B takes a big step forwards with her right foot, bends her knee to form a right bow stance; at the same time, with her right hand presses A's right hand wrist downwards to the lower part of her bodyside, and with her right shoulder squeezes forwards against A's right shoulder, raising her left hand behind the side of the body, looking forwards(Fig. 123 and 124).

要點：乙翻拿甲腕時，右臂先沈肩前送，再內旋上舉，反手（掌心向右，虎口朝下）擒拿下採。左腳後撤距離，以回靠招法到位為準。

Key points:While B flips and grabs A's wrist, she first sinks her right arm and extends forwards, then rotates inwards and raises it upwards, with her backhand (palm to the right and tiger's mouth facing down), tackling and grabbing. The retreating distance of the left foot is subject to the coordination of tactic.

(六五) 甲換步左掤 (圖 125、126)
A-change steps and ward off left(Fig.125,126)

招法: 撤步右採,上步左掤打。

Tactics: change step, press to the right and ward off, and hit to the left.

動作: 1、乙靠近時,甲坐腿縮身,上體右轉,使乙落空(參見圖124)。隨之,右腳撤至左腳內側,提起左腳。同時右臂內旋,右手反拿乙右腕,經胸前向右牽引;左手收於左腰間,掌心向上。目視對(東)方(圖125)。

Movements: a.While B approaching, A sits on his leg and retracts, and turns his upper body to the right to cause B attack ineffective (Fig.124).then, withdraws his right foot to the inside of his left foot and lifts it; at the same time, rotates his right arm inwards, with his right hand tackles B's right wrist, and pulls to the right through the front of the chest, puts his left hand on the left waist, palm facing upwards, looking at the opponent(the East)(Fig.125).

圖 125

2、上勢不停，左腳上步至乙右腳後外側，屈膝前弓成左弓步。同時左前臂經乙右腋下向前掤打乙胸，掌心向內，力點在前臂外側；右手採拿乙腕至右胸前。目視對（東南）方（圖126）。

b.Without stopping, A steps up his left foot to the outside of B's right foot rear bends his knee to form a left bow stance; at the same time, with his left forearm wards off and hit forwards to B's chest through B's left armpit, palms facing inwards, the the point of force concentrating on the outside of his forearm, and with his right hand, grabs B's wrist to the front of B's right chest, looking at the opponent(the Southeast) (Fig. 126).

圖 126

要點：掤是太極拳八法第一法。原意為手臂半屈成弧舉在體前，像盾牌一樣阻擋對手，保護自己。此處掤不是阻擋，而是前臂掤打對方，屬於進攻招法。此處的採也不是向下採，而是採領對方向後牽引。定勢時沈肩、含胸、頂頭，右臂撐圓。步型視距離而定，可弓步可半馬步。

Key points: Ward-off is the first technique of the eight techniques of Taijiquan. The original meaning is to hold the arm in an arc in front of the body, blocking the opponent like a shield and protecting oneself. It does not mean blocking in this movement, but warding off with the forearm to hit the opponent, which is an offensive tactic. The Cai here is not a downwards picking but pulling and leading the opponent backwards. While adopting fixed posture, you should lower your shoulders, contract your chest, lift your head, and the right arm should be rounded. The foot form depends on the distance, and it can be a bow stance or a half horse.

（六六）乙退步右攔（圖 127）
B-step backward and block right(Fig.127)

招法：退步雲手右攔。

Tactics: step backwards and cloud hand, block to the right.

動作：甲掤打逼近，乙順勢坐腿縮身（參見圖126），右腳後退一步成左弓步。隨之上體右轉，右手翻拿甲的右腕向右牽領；左手粘住甲右肘向右雲撥。目視右前（西北）方（圖127）。

Movements: While A's attack approaching, with the trend B sits her leg and retracts (Fig.126), and takes a step backwards with her right foot, then turns her upper body to the right, and flips her right hand, and tackles A's right wrist to drag to the right, sticks her left hand to A's right elbow and block to the right, looking forwards to the right (the Northwest)(Fig. 127).

圖 127

要點：退步轉體與雙手雲擺要協調一致。退步步幅依勢而定，可大可小。

Key points: The retreating backwards and turning the body should be harmonized with the cloud hand. The retreating stride depends on the posture which can be large or small.

(六七) 甲上步右掤 (圖 128、129、130)
A-step forward and ward off right(Fig.128-130)

招法: 上步左採，弓步右掤打。

Tactics: step up and grabs to the left, ward off right, and hit.

動作: 1、甲左手經胸前從右臂下穿出，反手抄拿乙左腕外側。隨之右腳上步落於乙右腳後側，上體左轉。左手採拿乙腕向左牽領；右手置於胸前蓄勢待發，掌心向內。目視對方（圖128、129）

Movements:a.Through in front of his chest A pierces out his left hand under his right arm, and tackles with his backhand the outside of B's left wrist, then steps his right foot forwards and drops at the side of B's right foot rear, and turns his upper body to the left. with his left hand grabs B's wrist and drags to the left, puts his right hand in front of his chest, gathering energy and ready to go, palms facing inwards, looking at the opponent(Fig.128, 129)

圖 128

圖 129

圖 130

　　2、隨之屈膝前弓成右弓步。右前臂經乙左臂下向前掤打乙胸部，掌心向內，力點在前臂外側；左手採拿乙腕至身體左胸前。目視對（東北）方（圖130）。

b.Then A bends his knee to form a right bow stance, moves his right forearm through B's right armpit to hit forwards on B's chest, palm facing inwards, the point of force concentrating on the outside of his forearm, with the left hand grabs B's wrist to in the front of B's left chest, looking at the Opponent (the Northeast)(Fig. 130).

要點: 參見（六五）動。

Key Points: see movement (56)

(六八) 乙退步左攔 (圖 131)
B-step backward and block left

招法: 退步雲手左攔。

Tactics: step backwards, cloud hand, and block to the left.

動作: 甲掤打逼近，乙順勢坐腿縮身（參見圖130），左腳後退一步成右弓步。隨之上體左轉，左手翻拿甲的左腕向左牽領；右手粘住甲左肘向左雲撥。目視左前（西南）方（圖131）。

Movements: While A's attack approaching, with the trend B sits on her leg and retracts (Fig. 130), and takes a step backwards with her left foot, then turns her upper body to the left, and flips her left hand, and tackles A's left wrist to drag to the left, sticks her right hand to A's left elbow and block to the right. Looking forwards to the left(the Southwest) (Fig. 131).

圖 131

要點: 參見（六六）動。

Key Points: see movement (66)

(六九) 甲披身掤打 (圖 132、133、134)
A-fists roll over body and ward off and hit(Fig.132-134)

招法: 跟步左採，披身逼近，掤打對方。

Tactics: Follow - step and grab to the left, fists roll over the body and hit

動作: 1、甲左腳跟近半步，重心後移，上體左轉。同時左手內旋，反手拿住乙左腕向左採領；右臂披身置於乙左臂下，掌心向內。右腳前移半步，披身側向逼近對方，伺機待發（圖132）。

Movements: a.A's left foot follow a half step, shifts his bodyweight backwards, and turns his upper body to the left; at the same time, rotates his left hand inwards, tackles B's right wrist with backhand to pull to the left, moves his right arm to under B's left armpit, palm facing inwards, moves his right foot a half step forwards, shifts his body to approach the opponent from sideways, waiting for the opportunity (Picture 132).

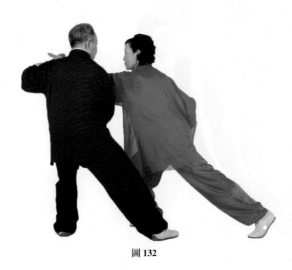

圖 132

2、上勢不停，甲腰腿發力，右前臂抖彈擊打乙胸部，使乙騰空後退。目視對（東北）方（圖133）。

b.Without stopping, A exerts the force on his waist and legs, and with his right forearm hits with bounce B's chest, making B vacate and backwards, looking at the opponent(the Northeast)(Fig. 133 and 134).

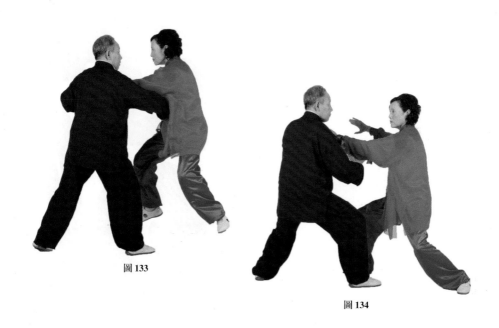

圖 133

圖 134

要點：本勢可採取抖彈發力掤打，亦可不發力掤打。發力時甲乙脫手分開，乙跳步騰空後退（圖133）。不發力時乙重心後坐，滑步後退，成虛步或半馬步（圖134）。

Key points: In this movement, you can apply bouncing hit with force or without force. When applying force, A and B separate each other, and B jumps backwards (Fig. 133). When not applying force, B sits backward and slides a step backwards to form an empty stance or a half-horse stance(Fig. 134).

(七十) 乙白蛇吐信 (圖 135、136、137)
B-White Snake Spits Tongue(Fig.135-137)

招法: 右拳搬壓，左掌撲面，右拳沖打。

Tactics: the right fist deflects and presses, the left palm slaps the face, right fist punches.

動作: 1、甲搠打時，乙跳步或滑步後成右虛步。同時左手內旋舉於頭側上方；右手握拳搬壓甲右腕，拳心朝上。甲同時成虛步或半馬步。二人目光東西對視（圖135）。

Movements:a.While A is hitting, B jumps or slides backwards to form a right empty stance; at the same time, rotates left hand inwards and raises at the upper side of her head, clenching her right fist to deflect and press A's right wrist, the fist facing upwards, meanwhile, A forms an empty stance or a half-horse stance, looking at each other (Fig. 135).

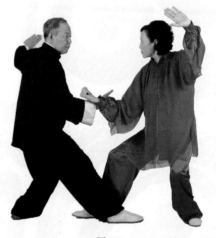

圖 135

2、乙右腳活步前移，屈膝前弓，上體右轉前俯。同時左掌攻擊甲面部，掌心朝前。甲仰身坐腿，左手搠架乙撲面掌，掌心朝內（圖136）。

b.B makes a free moving step of her right foot, bends her knee to bow forwards, turns her upper body to the right, and leans forwards; at the same time, with her left palm attacks A's face, A leans his upper body backwards and sits on his leg, and fends off hand B's slaping palm of his face with his left hand(Fig. 136).

圖 136

圖 137

3、上勢不停，乙重心後移，上體左轉屈蹲成馬步。右拳立拳沖打甲腹部，拳眼朝上。甲坐腿轉腰，右拳外旋，向右搬圧乙右拳，拳心向上。二人皆目視右拳（圖137）。

c. Without stopping, B shifts her bodyweight backwards, turns her upper body to the left, and squat into a horse stance, with vertical right fist(the fist eye facing upwards) punches to A's abdomen, looking at her right fist (Figure 137).

要點： 本動為三招連發：虛步右拳搬圧—弓步左掌撲面—馬步右拳沖打。要求攻防清楚，周身一體。同時甲要相應接招，配合嚴密，不可有攻無防，攻防脫節。

Key points: This movement is a three-tactics burst: deflection and press with the right hand in the empty stance - slaping face with left palm in bow stance - punching the right fist in horse stance. It requires clear offensive and defensive, upper body and lower body should well cooperate. The whole body should act like one. At the same time, A should respond to the tactics accordingly, cooperate closely. The offensive and defensive should be reasonable to avoid disconnection.

第四段 section 4

(七一) 甲高探馬 (圖138、139、140)
A-High Pat on Horse(Fig.138-140)

招法: 左掤架右搬攔，上撲面下踢腿。

Tactics: ward off left and deflect and block right in defend tightly, slaping face high with palm and kicking down.

動作: 1、乙上動進攻時，甲先以左前臂掤架乙撲面掌（參見圖136）。再以右拳向外搬攔格擋，搬開乙沖拳（參見圖137）

Movements: a.When B attacks in the previous movement, A first ward off B's squashing face with his left forearm(Fig. 136), then block outwards with his right fist to move away from B's punching (Fig.137)

2、隨之，甲右腳向前活步移動，腳尖外撇，上體右轉。同時右拳內旋變掌，拿住乙右腕下採；左掌直奔乙面部撲打，掌心斜向前下方。目視對方（圖138、139）。

b.Without stopping, A makes a free moving of the right foot forwards, the toes pointing outwards, and turns his upper body to the right; at the same time, rotates his right fist inwards to grab B's right wrist and pull it downwards, slap with his left palm g straight to B's face, the palm tilting forwards and downwards, looking at the opponent(Fig.138, 139).

圖 138

130

圖 139

圖 140

3、隨之，甲左腳提起用腳尖踢向乙右小腿脛骨。目視對（東）方
（圖140）。

Then, A lifts his left foot and kicks B's right calf tibia with his toe, looking at the opponent(the East)(Fig. 140).

要點： 撲面掌力點在掌心；踢（分）腳力點在腳尖。

Key Points: The point of force of slap-face-palm is on the center of the palm. The point of force of the kicking foot(separating foot) is on the toes.

（七二）乙分手踩腿（圖141）
B-separate hands and stamp leg(Fig.141)

招法：雙手分撐，右腳橫踩對方小腿。

Tactics: Separates hands and stamp with right foot horizontally to block the opponent's calf

動作： 1、甲上勤撲面掌擊來時，乙坐腿閃身，左手經右前臂下穿出至甲右腕內側。隨之兩臂內旋，兩掌外撐分開甲雙臂，掌心向外。同時右腳後移成右虛步，目視對（西）方（參見圖139、140）

Movements: a. While A's slaping face-palm approaching, B sits on her leg to dodge, pierces out his left hand through under the right forearm to the inside of A's right wrist, Then rotates both arms inwards, props her two palms outwards to separate A's two arms, her palms facing outwards; at the same time, moves her right foot backwards to form a right empty stance, looking at the opponent(the West)(Fig.139 and 140).

圖 141

2、甲左腳踢來時，乙提起右腳，腳尖外展，腳底著力，橫腳下踩甲左小腿脛骨，阻擋對方。目視右腳（圖141）。

b.While A's left kick approaching, B lifts her right foot, swings the toes outwards, the point of force concentrating on the soles of her foot, steps downwards horizontally the shin of A's left calf to block the opponent, looking at her right foot (Fig. 141).

要點：踩腿又稱踩腳，是武術常用腿法。用腳底向前橫踹對方小腿，阻截破壞對方的進攻。

Key Points: Stepping leg is also called stepping foot, which is a common leg technique in martial arts. It is to move the sole forwards and kick horizontally the opponent's calf.

(七三) 甲轉身擺蓮 (圖 142、143、144)
A-Turn and sweep the Lotus(Fig.142-144)

招法：右後轉身，右掌擺打，右腳擺踢。

Tactics: turn right to the back, swing right palm to hit in the direction of the right, and swing right foot to kick in the direction of the right.

動作: 1、甲乘勢轉腰合胯，兩臂收攏，以右腳掌為軸向右後轉身，左腳內扣落在右腳前外側。隨之重心左移，上體繼續碾腳右轉至180度。右臂隨轉體右擺，以掌背搧打乙頭部；左臂左擺至體側。目視對（東）方。乙迅速舉右掌挑撥阻擋甲右掌（圖142、143）。

Movements: a.A takes advantage of the position, and turns his waist and close his hips, closes two arms, turns 180 degrees from the right to the back with the sole of his right foot as the axis, and buckles his left foot inwards and drops at the front and outside of his right foot, then shifts his body weight to the left, with grinding of his right foot, turns continuously his upper body. With the rotation of the upper body, swings his right arm to the right, fans B's head with the back of his palm, swings his left arm to the left to the side of his body, looking at the opponent(the East). B quickly raises her right palm to block upwards A's right palm (Fig.142, and 143).

圖 142

圖 143

2、隨之，甲再自左向右外擺右腿，用腳外側擊打乙腰部。乙右手捏成勾手，向下勾開甲的右腳。二人目光對視（圖144）。

b.Then, A swings his right leg from left to right and hits B's waist with the outside of his foot. B pinches his right hand into a hook and hooked A's right foot downwards. A and B are looking at each other (Fig. 144).

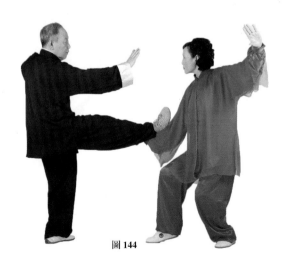

圖 144

要點： 甲落腳轉身時，轉腰、合胯、收臂三者合為一體。碾腳轉身後，轉腰、擺臂、擺腿三者協調配合。不可身手脫節。乙的上掛下勾與甲的搧掌擺腿攻擊要適時合度，配合嚴密。不可先防後攻，也不可有攻無防。

Key Points: When A drops his foot and turns around, the three movements, the turning waist, the closing hips, and the arms should be integrated into one. When He grinds his foot and turns his waist, the three movements, the rotating waist, the swinging arms and the leg should be well-coordinated and harmonized. The hands and body should be well connected. B's blocking upwards and hooking downwards and A's attacks of the fanning palm and swinging leg should be timely and properly, closely coordinated. It is recommended neither to defend first and then attack, nor to attack without defense.

（七四）乙單鞭下勢（圖 145）
B-the Single whip and creeps down(Fig.145)

招法： 舖步蹲身，穿掌擊襠。

Tactics: squat down and drop stance, pierce palm down to the crotch.

動作： 1、上動甲擺掌搧來時，乙挑掌上掛（掌心向內，指尖朝上）阻擋；甲擺腿擊來時，乙勾手下掛（五指捏攏，勾尖朝下）勾開（參見圖143、144）。

Movements: a. While A's fanning palm-attack approaching in the previous move, B picks up the palm to block upwards (palm facing inwards, fingertips facing upwards) to block, while A's swing leg-attack approaching, B hooks away with her hands downwards(five fingers pinch together, hook's tip facing downwards) (Fig.143、144).

2、隨之，乙上體右轉，右腿屈蹲，左腳側伸成左舖步。同時左掌側立，四指並攏向左，姆指朝上，向左側穿伸攻擊甲襠部。力點在指尖，右勾手舉於體右側，高與肩平。目視對（西南）方（圖145）。

b.Then, B turns her upper body to the right, squats down with her right leg, and stretches her left foot sideways into a left crouch stance; at the same time, pieces her left palm (four fingers together to the left, thumbs up) sideways to the left to attack A's crotch, the point of force concentrating on the fingertips, and the right hook are held on the side of her body at shoulder-height, looking at the opponent(the Southwest)(Fig.145).

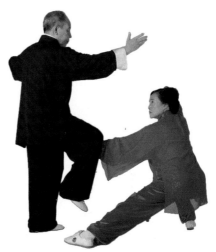

圖 145

要點： 掛和穿都是武術招法。掛又稱勾掛，是防守招法，用手或器械勾開對方。穿是進攻招法，手或器械沿身體、手臂或大腿向前伸出攻擊對方。此勢舖步應依對方高度全蹲舖步或半蹲舖步。

Key Points: Both Gua and piercing are the techniques of martial arts. Gua is also known as hooking, a kind of defensive technique that uses hands (or equipment) to hook away from the opponent. Piercing is an offensive technique, where the hand (or equipment) stretches forwards along the side of the body, arm, or thigh to attack the opponent. The crotch stance in this movement can be a fully squatting crotch stance or a half-squatting crotch stance, depends on the opponent's height.

(七五) 甲退步栽捶 (圖146)
A-step backward and punch downward(Fig.146)

招法: 退步俯身，右拳向前下方栽打。

Tactics: bend leg and lean body forwards, plunge right fist forwards and downwards.

動作: 乙穿掌插來時，甲速收右腳向後退步，左腳扭直，左腿屈弓成左弓步。同時上體右轉前傾，左掌向前採拿乙的左腕；右手握拳收至肩上，再向前下方栽打乙的頭部。拳心向內，力在拳面。目視前（東北）下方（圖146）。

Movements: While B's piercing palm approaching, A quickly retracts his right foot and steps backwards, twists his left foot straight, and bends his left leg to form a left bow stance; at the same time, turns his upper body to the right and leans forwards, and moves his left palm forwards to grab B's left wrist, clench his right fist and moves it to the shoulder, then plunges it forwards and downwards to slam B's head, The heart of his fist facing inwards, the point of force concentrating on the face of his fist, looking downwards to the front (the Northeast)(Fig. 146).

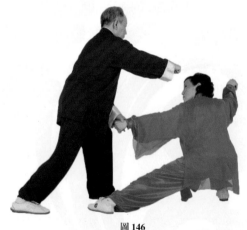

圖 146

要點: 栽捶是太極拳五捶之一，拳自上向下或向前下方的沖打。

Key Points: Zai Chui is one of the five punches of Taijiquan. Punching fist from the top downwards or from the top downwards to the front.

(七六) 乙換步斜飛勢 (圖 147、148、149)
B-shift feet and flying the oblique posture(Fig.147-149)

招法: 換步左採手, 右橫捌。

Tactics: change steps and grab hands downwards to the left, tear horizontally to the right.

動作: 1、甲拳擊來時, 乙向右閃身, 左腳收回半步, 腳尖外展, 隨之右腿蹬地起身, 上體左轉; 同時左臂內旋, 左手翻拿甲左腕向左牽帶; 右勾手變掌舉於體側。目視左手 (圖147) 。

Movements: a.While A fist approaching, B flashes to the right, retracts her left foot for a half step, swings his toes outwards, then press her right leg to the ground to stand up, and turns her upper body to the left; at the same time, rotates her left arm inwards, flips her left hand and tackles A's left wrist to drag to the left, unclench her right hook and holds at the side of her body, looking at her left hand (Fig.and 147).

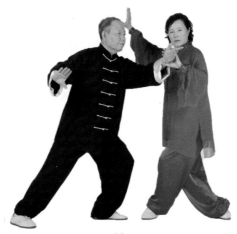

圖 147

2、上勢不停，右腳提起向前上步，落至甲左腳後外側，屈膝前弓成右側弓步。同時右手經甲左腋下穿伸至甲胸前，隨上體右轉及右腿弓蹬之勢，向右橫捌，使甲後仰。目視對方。此時二人皆胸向南（圖148、149）。

b.Without stopping, B lifts her right foot and steps forwards, drops at the inside of A's left foot rear, bends her knee to form a side right bow stance; at the same time, pierces her right hand through under A's left armpit and stretches out to in front of A's chest, then turns her body to the right and arch her right leg to tear to the right which causes A to lean backwards, looking at the opponent. At this time, the chests of both A and B are facing the South (Fig.148 and 149).

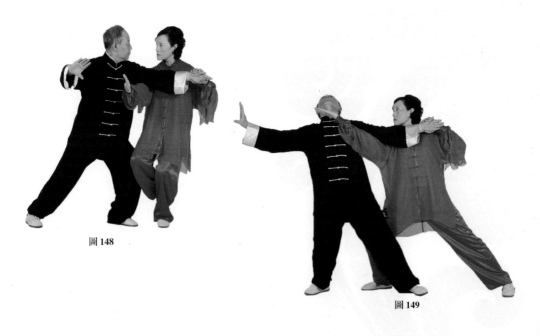

圖 148

圖 149

要點：本勢招法為橫捌，將對方掀翻、扭轉。不同於（二三）野馬分鬃的向前分靠。

Key Points: The tactic in this movement is to tear the opponent horizontally, to overturn and twist the opponent. It is different from Wild Horse Parts Manne(movement 22) which separates and presses forwards.

（七七）甲左贯拳伏虎（圖 150、151）

A-sweep left side and punch and tame(hit) the tiger(Fig.150,151)

招法：繞步至對方身後，左貫拳擊頭。

Tactics: circle step to behind the opponent and sweep left side and punch the head.

動作： 1、乙橫捌接近時，甲重心右移，提起左腳，上體左轉。同時右手抓住乙右腕向右下採；左手外旋握拳脫開乙的控製，擺至體側（圖150）。

Movements: a.While B's tearing approaching, A shifts his bodyweight to the right lifts his left foot, and turns his upper body to the left; at the same time, with his right hand grabs B's right wrist and pulls downwards to the right rotates his left hand inwards and clench the fist to get rid of B's control and swing to the side of the body (Fig.150).

2、甲左腳繞落在乙右腳後外側，重心前移成左弓步。同時左拳向前上方劃弧，貫打乙的頭部，力在拳面，拳眼斜向右下方；右拳下採乙右腕不變。目視左拳（圖151）。

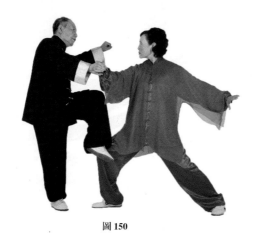

圖 150

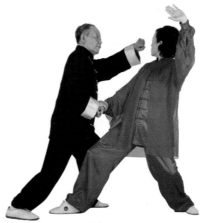

圖 151

b.A circles step with his left foot and drops it at the outside of A's left foot rear, shifts his bodyweight forwards to form a left bow stance; at the same time, draws his left fist in an arc forwards and upwards, hits on B's head, the point of force concentrating on the face of his fist, the fist's eye tilting downwards to the right, his right palm is pulling B's right wrist downwards unchanged. Looking at his left fist (Fig.151).

要點: 參见（十五）动。

Key Points: see movements (15)

(七八) 乙化打撇捶 (圖 152、153)

B-neutralize opponent's force point and turn body and throw fist (Fig.152,153)

招法: 左拿右化，弓步撇拳擊頭。

Tactics: tackle left and neutralize right, hit the opponent's head from the side in bow stance

動作: 1、在甲左拳擊來時，乙坐腿閃身（參見圖151），左手向前經右前臂下方穿出，翻腕內旋，反手抓拿甲的右腕，向左摘開甲的右手；繼而向右轉腰，右手握拳屈肘內旋，向右引化撥開甲的左拳。目視右拳（圖152）

Movements: a.While A's left punch approaching, B sits on her leg to dodge(Fig.151), moves her left hand forwards through under the right forearm and flip her wrist inwards, tackles A's right wrist with her backhand, and removes away A's right hand to the left, then turns her waist to the right. While clenching her fist and rotating inwards, bends her elbow, and intercepts A's left fist to the right, looking at her right fist (Fig.152)

2、上勢不停，左腿蹬伸，右腿屈弓成右弓步。同時向左轉腰，右臂外旋，用拳背向前撇打甲頭部。眼看前（東）方（圖153）。

b. Without stopping, B stretches her left leg, and bends her right leg to form a right bow stance; at the same time, turns her waist to the left, rotates her right arm outwards, and with the back of her fist punches forwards to hit A's head, looking forwards(the East) (Fig.153).

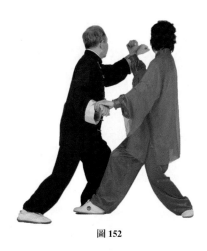

圖 152

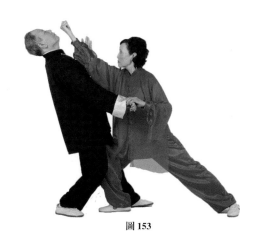

圖 153

要點： 乙的招法是先化後打。先化解甲的進攻，再劈拳反攻。只有在身法、臂法、手法的協調配合下，才能保證招法準確有效。

Key point: B's tactic is to neutralize first, then attack. Only when bodywork, arm work, handwork are well-coordinated and harmonized, the technique can be applied accurately and effectively.

(七九) 甲右倒攆猴 (圖 154、155)
A-step back ape fend off -right(Fig.154,155)

招法: 左掌化按，右掌撲面。

Tactics: neutralize with left palm and press, slap face with the palm.

動作: 1、乙拳劈近時，甲坐腿仰身，重心後移（參見圖153）。左拳變掌粘住乙右肘，隨轉腰向右化按，使乙拳落空；右掌同時向左向上舉起。目隨視乙右拳（圖154）。

Movements: a.While B's fist-attack approaches, A sits on his leg and leans backwards, and shifts his bodyweight backwards (Fig.153), unclench his left fist to stick to B's right elbow, then with the turning of his waist to neutralize and press to the right to cause B's fist ineffective, at the same time, raises his right palm upwards to the left, looking at the B's right fist(Fig. 154).

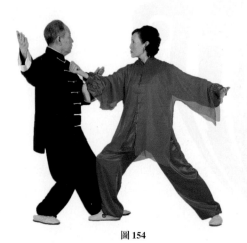

圖 154

2、上勢不停，重心前移，上體左轉。右手經肩上向前撲打乙面部，掌心朝前，掌指斜向上；左手壓製乙右臂不變。目視對（東）方（圖155）。

b.Without stopping, A shifts his bodyweight forwards, and turns his upper body to the left, swings his right palm forwards and slaps on B's face through the shoulders, his palm facing forwards and the finger of his palm tilting upwards, with his left hand suppresses B's right arm unchanged, looking at the opponent(the East)(Fig.155).

圖 155

要點：左化按要與坐腿右轉腰一致；右撲打要與弓腿左轉腰一致。定勢步型成左弓步或半弓步。

Key points:The neutralization with the left hand and the pressing should be harmonized with the sitting leg and rotation of the waist to the right. The slaping with the right hand should be harmonized with the bow stance and rotation of the waist to the left. The foot form of the fixed posture is a left bow stance or a half-bow stance.

(八十) 乙右雲手 (圖 156)
B-Cloud Hands right(Fig.156)

招法: 雙手向右雲撥甲右臂。

Tactics: cloud hands and pull A's arm to the right.

動作: 甲掌撲近時,乙坐腿閃身,右拳變掌,前臂內旋,上體右轉,反手(掌心向右,姆指朝下)拿住甲的右腕向右牽帶;同時左手粘附甲的右上臂向右雲撥。頭隨體轉,目視右(西北)手(圖156)。

Movements: While A's palm approaching, B sits on her leg to dodge(Fig.155), unclench her right fist, rotates the forearm inwards, turns her upper body to the right, tackles A's right wrist with the backhand(palm to the right, thumbs down)to drag to the right; at the same time, sticks her left hand to A's upper right arm and cloud hand to block it away to the right, her head moving with the tuning of her body, looking at her right hand (the Northwest) (Fig.156).

圖 156

要點: 雲撥與坐腿、轉腰協調一致。

Key Point: The cloud hands should be coordinated and harmonized with the sitting leg and the rotation of the waist.

（八一）甲左倒攆猴（圖 157、158）
A-step backwards ape fend off -left(Fig.157,158)

招法：退步左撲面掌。

Tactics: step backwards and slap the left palm.

動作：1、甲左腳後退一步，左手上舉；右臂掤住乙的兩手（圖157）。

圖 157

Movements: a.A moves a step backwards with his left foot and raises his left hand, wards off B'stwo hand with his right arm (Fig.157).

2、上勢不停，甲上體右轉，前腳扭直，屈膝前弓，上體前探。左手經肩上向前撲打乙面部；右臂仍在腹前掤住乙雙手。目視前（東）方（圖158）。

b.Without stopping, A turns his upper body to the right, twists the front foot straight, bends his knee and bows forwards, and leans his upper body forwards, moves his left hand over the shoulder and slaps forwards on B's face, his right arm is still in front of his abdomen blocking B's hands, looking forwards (the East)(Fig. 158).

圖 158

要點：定勢時，甲可右腳扭直成小号步，也可稍向前移動成右号步。

Key points: While adopting fixed posture, A twists the front foot straight to form a right bow stance, he can also make a free moving step forwards slightly to form a right bow stance.

（八二）乙左雲手（圖159）
B-Cloud Hands - left(Fig.159)

招法： 上步雙手向左雲撥甲左臂。

Tactics: step forward and cloud hands to pull A's left arm to the left.

動作： 甲掌撲近時，乙坐腿閃身，左腳上步，上體左轉。同時左手繞至甲左腕外側，翻掌反手採拿甲左腕向左牽帶；右手粘附甲的左上臂向左雲撥。頭隨體轉，目視左（西南）手（圖**159**）。

Movements: While A's slapping palm approaching, B sits on her leg to dodge (Fig.158), steps up with her left foot, and turns her upper body to the left; at the same time, circles her left hand to the outside of A's left wrist, turns over her palm and with the backhand tackles A's left wrist to drag to the right, and sticks her right hand to A's upper left arm and cloud hand to block it away to the left, her head moving with the tuning of her body, looking at her left hand(the Southwest) (Fig. 159).

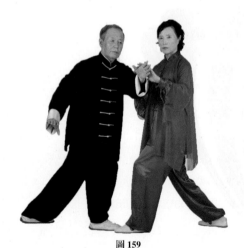

圖 159

要點： 此勢左腳上步至甲右腳外鍘，視距離控製步幅，勿過勿不及。

Key points: In this movement, steps up the left foot to the outer side of A's right foot. The stride length depends on the distance, neither too long nor short.

（八三）甲右倒攆猴（圖 160、161）
A-step back ape fend off-right(Fig.160,161)

招法：退步右撲面掌 。

Tactics: Step backwards and slap face with the right palm.

動作：甲右腳後退一步，左腿屈膝前弓，上體左轉。右掌上舉，經肩上向前撲打乙面部；左臂在腹前掤住乙的雙手。目視前（東）方（圖160、161）。

Movements: A takes a step backwards with his right foot, bends his left leg and bows knee forwards, and turns his upper body to the left, raises his right palm upwards, and moves his left hand over the shoulder and slaps forwards on B's face, looking forwards(the East)(Fig.160 and 161).

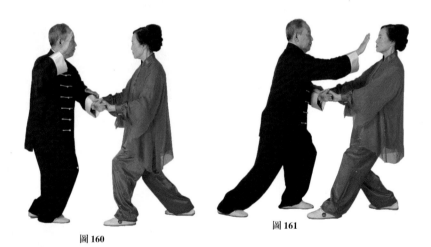

圖 160　　　　　圖 161

要點：定勢時上體前傾，步型為左弓步或小弓步，與手法協調配合，勿過度勿落空。

Key points: While adopting fixed posture, lean the upper body forward. The foot form can be applied either a left bow stance or a small bow stance which is to be well-coordinated and harmonized with the handwork, neither too excessive nor empty.

(八四) 乙上步七星 (圖162、163)

B-Scoop Palm and Creeps Down(Fig.162,163)

招法： 雙拳交叉，上架下踢。

Tactics: cross fists, ward off high, and kick lower.

動作： 1、甲掌擊來，乙坐腿閃身，雙手握拳，腕關節交搭，右拳在外，左拳在內，成斜十字形，向上迎架甲右掌。目視前方（圖162）。

Movements:a.While A's palm-attack approaching, B sits on her leg to dodge(Fig.161), clenches her two fists, puts her wrists together, her right fist is at the outside, and her left fist is at the inside to form an oblique cross shape, fends off upwards A's right palm, looking forwards(Fig.162).

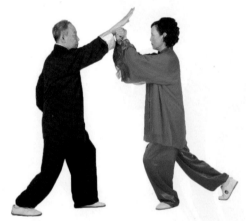

圖 162

2、隨之，提起右腳，用腳尖踢向甲的左膝關節。目視前（西）方（圖163）。

b. Then, lifts his right foot and kicks A's left knee joint with the toe, looking forwards(the West).

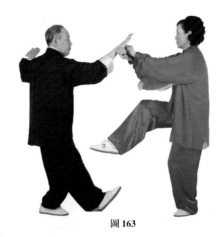

圖 163

要點：十字架拳時，兩臂屈肘上舉至頭前，右拳心斜朝前，左拳心斜朝後。

Key points: While adopting cross fists, raises both arms to the front of her head with bent elbows, the heart of the right fist tilting forwards and the heart of the left fist facing backward.

（八五）甲海底针（圖 164、165）
A-Needle at Bottom of the Sea(Fig.164,165)

招法：右採腕，左插襠。

Tactics: grab wrist right and insert crotch left.

動作：1、乙右腳踢近時，甲坐腿縮身，重心後移，收提左腳。同時，右手下採乙右腕至腹前；左手粘在乙右肘外側。乙隨之右腳前落成半馬步（圖164）。

Movements:a.While B's right kick approaching, A sits on his leg and retracts (Fig.163), shifts his bodyweight backwards, and closes his left foot and lifts it; at the same time, grabs B's right wrist with his right hand and pulls downwards to in front of his abdomen, sticks his left hand to the outside of B's right elbow, then B drops her right foot forwards to form a half-horse stance (Fig.164).

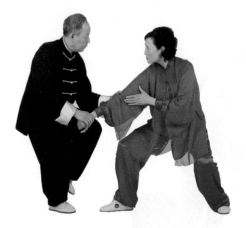

圖 164

2、上勢不停，甲屈腿蹲身，左腳前落至乙身後成半馬步。左掌成側掌經乙右臂下插向乙襠部，力在指尖，掌心向前（南）。乙左掌迅速在腹前迎拿攔截甲左腕。二人胸向朝南，目光東西對視（圖165）。

b.Without stopping, A bends his leg and squats down, and drops his left foot forwards to the back of B to a half-horse stance, with the side of his left palm inserts B's crotch, the point of force concentrating on the fingertips, the palm facing forwards (the South). B immediately moves her left palm to in front of her abdomen to intercept A's left wrist; at this time, the chests of both A and B are facing the South, looking at each other(the East and the West) (Fig.165).

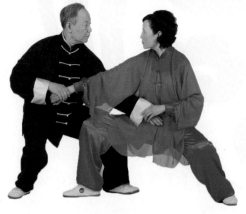

圖 165

要點： 插掌是武術中攻擊性手法。側掌自上向下或自後向前攻擊對手，力在指尖。本勢也可做成撩掌，側掌自後向前、向上攻擊，力點在掌沿虎口一側。本動定勢時二人側身交錯，胸向朝南。步型成半馬步或偏馬步。

Key Points: Inserting palm is an offensive technique in martial arts. Attack the opponent with the side-palm from top to bottom or from back to front, with the point of force at fingertips. In this movement, you can also adopt an arc palm to attack with the side-palm from back to front and upwards, with the point of force at the side of the palm along the side of the tiger's mouth. In this move, the two persons cross sideways with their chests facing south. The foot form is a half-horse stance or biased horse stance.

（八六）乙扇通背 (圖 166、167)
B-fan the arm (Fig.166,167)

招法： 換步右提手，左推掌。

Tactics: change steps and lift the right hand, push the left palm forwards.

動作： 1、甲上動採手插掌時，乙右腳前落，上體左轉，左掌迎截甲左腕（參見圖165）。

Movements: a.While A pulling and inserting his hand into B's crotch in the previous movement, B drops her right foot to the front, turns her upper body to the left, and with her left palm intercepts A's left wrist(Fig.165).

2、本動，乙右手下沈，緩解甲力，隨即內旋翻掌，反手拿住甲右腕，提至頭前上方；左手收至胸前。同時重心後移，上體右轉，右腳後撤至左腳內側，提起左腳（圖166）。

b.In this movement, B sinks her right hand to neutralize the strength of A, then turns her palm inwards to tackle A' right arm with her backhand, and lifts it to the front of the head, moves her left hand to in front of her chest; at the same time, shifts her bodyweight backwards, turns her upper body to the right, and withdraws her right foot to the inside of her left foot (Fig. 166).

3、左腳迅速前上一步，重心前移成左弓步。同時左手向前推擊甲的胸部，掌心朝前。目視前（西）方（圖167）。

c.She moves her left foot a step forwards quickly and shifts her bodyweight forwards to form a left bow stance; at the same time, pushes her left hand forwards on A's, her palm facing forwards, the point of force at the base of the palm, looking forwards(the West) (Fig.167).

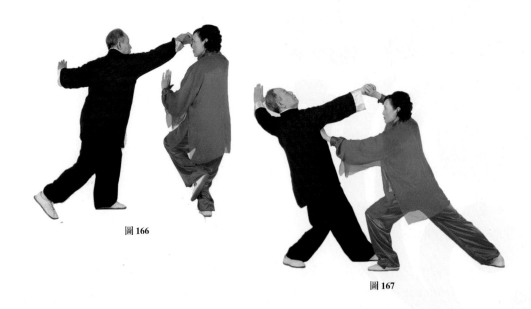

圖 166

圖 167

要點：兩腳前後換步與兩手上提前推協調一致，不可脫節。

Key points: Changing steps back and forth between the two feet is to harmonize with lifting two hands and pushing hands forwards, and should not be disconnected.

（八七）甲手揮琵琶（圖 168)
A-Strum the Lute(Fig.168)

招法：坐腿縮身，合手撅臂。

Tactics: on the leg and retract the body,close hands and pout with arm.

動作：甲坐腿縮身，含胸收腹，上體右轉，重心後移，左腳尖翹起成虛步。同時右手反拿乙的右腕，外旋下採至腹前；左手前伸附在乙右肘關節外側，合力撅乙右臂，目視對（東）方（圖168）。

Movements:A sits on his leg and retract his body, contracting his chest and abdomen, turns his upper body to the right, shifts his bodyweight backwards, and his left toes lifting; at the same time, with his right hand tackles B's right wrist, and rotates outwards and pulls downwards to in front of his abdomen, extends his left hand to stick to the outside of B's right elbow joint, apply force together to bend B's right arm, looking at (the East)(Fig.168).

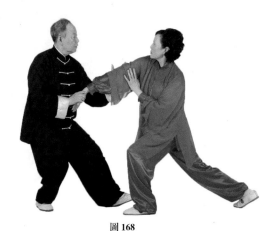

圖 168

要點：此勢最後形成反關節擒拿撅臂，步型為腳跟著地的左虛步。

Key Points: At the end of this movement forms an anti-joint tackling arm and bends the arm. The step form is a left empty stance, resting the heel on the ground.

(八八) 乙彎弓射虎 (圖 169、170)
B-curved bow to shoot tiger(Fig.169,170)

招法: 向右跨步，右手上提，左手沖拳。

Tactics: Step to the right, lift the right hand, punch with the left fist.

動作: 1、乙沈肩屈肘，右手外旋翻拿甲右腕。隨之右腳屈膝提起，上體右轉，右手內旋上提甲右腕至頭側；左手握拳收於腰間。甲隨之上體左轉，左腿屈提。二人目光對視（圖169）。

Movements: a.B sinks her shoulder and bends her elbow to neutralize A's attack on her arm, and rotates her right hand outwards to tackle A's right wrist (Fig.168). Then bends her right knee and lifts her left foot, turns her upper body to the right, and rotates her right hand inwards and lifts to the side of the head, clench her left fist and moves to the side of her waist. Then A turns his upper body to the left, and bends his left leg and lifts it. Both A and B are looking at each other (Fig.169).

2、上勢不停，乙右腳向右（北偏東）跨步下落，屈膝前弓成右弓步。右手拿住甲右腕繼續內旋向右上方提領；左拳自腰間向前沖打甲的右肋，拳眼朝上。此時甲也向左（北偏東）跨步成左弓步。二人目光對視（圖170）。

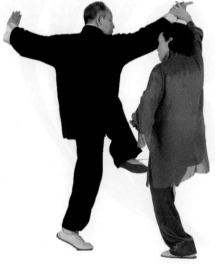

圖 169

b.Without stopping, B lands her right foot to the right, bending her knee to form a right bow stance, holding A's right wrist with her right hand, continues to rotate her right wrist and lift upwards, punches her left fist from her waist forwards to A's right rib, the eye of her fist facing upwards; at this time, A also steps to the left to form a left bow stance. Both A and B are looking at each other, A facing to the Southeast and B facing to the Northwest (Fig.170).

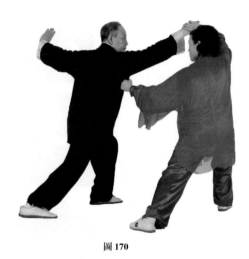

圖 170

要點: 此時二人步型皆為橫跨南北（稍偏東）的弓步。

Key point: At this time, both A and B are adopting a bow stance, spanning the North and the South (slightly to the East).

(八九) 甲虛步單鞭 (圖 171、172)
A-single wipe in empty stance (Fig.171,172)

招法： 左摘手，右掛肘，虛步勾手頂擊。

Tactics: pick up the left hand, hang the elbow on the right, and hit with a hook in an empty stance.

動作：1、甲上動隨乙勢向左跨步成左弓步（參見圖170）。隨之左手從右前臂下伸出，反手摘拿乙右腕。繼之，重心右移，右手捏成勾手，右臂屈肘右擺，用肘關節掛開乙左拳。目視右（東南）肘（圖171）。

Movements: a. A steps to the left with the trend of B(Fig.170), then stretches his left hand out from under his right forearm, and tackles with his backhand B's right wrist; at the same time, shifts his bodyweight to the right, pinches his right hand into a hook, bends the elbow with his right arm and swings to the right, hangs away B's left fist with his elbow joint, looking at the right elbow (the Southeast)(Fig.171).

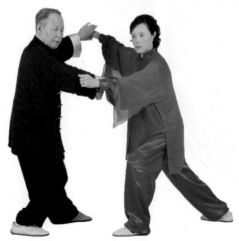

圖 171

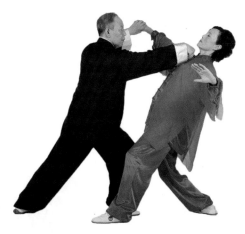

圖 172

2、上勢不停，甲右腳向前上步，插入乙兩腳之間，右勾手勾尖朝下，用勾頂向前頂撞乙下頷。目視對（東）方（圖172）。

b. Then, A steps his right foot forwards and inserts between B's feet, with the tip of the right hook facing downwards hits B's chin forwards with the top of the hook, looking at the opponent(the East)(Fig. 172).

要點：勾手是太極拳三大手型之一。五指自然伸直，指端捏攏成勾，腕關節彎屈。本動定勢步型可右弓步或右虛步，視雙方距離而定。

Key points:Hooking hands is one of the three major hand forms of Taijiquan. Straighten the five fingers naturally, pinch the ends of the fingers into a hook, and bend the wrist joints. The fixed posture in this movement can be applied either a right bow stance or a right empty stance, depends on the distance between the two parties.

(九十) 乙攔掌冲捶 (圖 173、174)
B-block palm and punch fist(Fig.173,174)

招法: 退步左攔掌，右冲拳。

Tactics: block palm left, punch right fist.

動作: 1、甲勾手頂來時，乙坐腿仰身，左拳變掌，閃開甲勾手（參見圖172）。隨之左腳收至右腳內側，提起右腳，上體右轉，左手向右推開甲左前臂；同時右手外旋握拳收到右腰側。目視對方（圖173）。

Movements: a.B sits on her leg and leans forwards to dodge away from A's hook (Fig.172), then unclenches her left fist, withdraws her left foot to the inside of her right foot, and lifts her right foot, turns her upper body to the right, and with her left hand pushes away A's left forearm to the right; at the same time, rotates her right hand outwards and clenches the fist to move to the side of her right waist, looking at the opponent(Fig.173).

圖 173

圖174

2、上勢不停，乙右腳後退一步，左腿屈弓成左弓步。同時上體左轉，右拳從左腕下向前伸出，沖打甲的右肋。目視前（西）方（圖174）。

b.Without stopping, B takes a step backwards with her right foot and bends his left leg to form a left bow stance; at the same time, turns her upper body to the left, and stretches her right fist forwards from under her left wrist, punching A's right rib, looking forwards (the West)(Fig.174).

要點：合理掌控右腳後退步幅，左腳也可以活步調整。一切要以沖拳到位，不過不空為準。

Key points: It is to control the retreat stride of the right foot reasonably, which can be large or small, and the left foot can also be adjusted to a free moving step. All are subject to the punching fist in place to avoid neither too excessive nor empty.

(九一) 甲穿掌锁喉 (圖 175、176)
A-thread (spiercing) palm and lock throat(Fig.175,176)

招法: 兩腳前後換步，右手勾掛，左手鎖喉。

Tactics: change steps back and forth between two feet, hook the right hand, and strangle hold throat with the left hand.

動作: 1、乙拳打來時，甲坐腿縮身，收腹含胸，使乙拳落空（參見圖174）。隨之上體右轉，右腳收提至左腳內側。右勾手屈臂下沈，順乙右臂外側向右後方勾開乙前臂；左手側舉於體側。目視右勾手（圖175）。

Movements: a.A sits on his leg and retracts his body, pulls in his abdomen and contracts his chest to cause B's fist ineffective (Fig.174), then turns his upper body to the right, withdraws his right foot to the inside of his left foot; with the right hook, bends his arm and sinks, and push along the outer side of B's right arm to hook B's forearm away to the right, and lifts his left hand at the side of his body, looking at the right hook. (Fig. 175).

圖 175

162

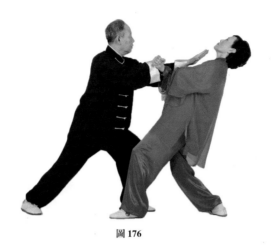

圖 176

2、右腳踏實，左腳上步，屈膝前弓成右弓步。左手收經腰間向前伸出，掌心朝下，虎口張開，向前鎖閉乙喉部。目視前（東方）（圖176）。

b.A steps his right foot on the ground firmly, steps up his left foot, bends his knee to form a right bow stance, stretches his left hand out from the waist's side (the palm facing downwards, the tiger's mouth opening) forwards to lock B's throat(Fig.176).

要點：勾掛是武術常用防守招法。用手或兵器向外撥開或向後勾開對方。鎖喉是武術常用進攻招法。用手或兵器壓迫對方喉部，使敵窒息。

Key points: Hooking hand is a common defensive technique in martial arts. Use a hand or weapon to block away and hook the opponent. Locking the throat is a common offensive technique used in martial arts. Use the hand or weapon to stab the opponent's throat to suffocate the enemy.

(九二) 乙如封似閉 (圖 177、178)
B-Apparent close up(Fig.177,178)

招法: 坐腿引化，弓腿前按。

Tactics: sit on the leg to neutralize the attack, bow leg, and press forwards.

動作: 1、甲左手將要叉到時，乙坐腿仰身，閃開甲手（參見圖176）。隨之左手從右前臂下穿出掤接甲右腕；右手下沈繞到甲右肘外側。隨上體左轉，雙手向左向後掤接引化，使甲陷於背勢。頭隨體轉，目視左（南）側（圖177）。

Movements:a. While A's left hand approaching, B sits on her leg and leans forwards to dodge away from A's hand, (Fig.176), then pierces her left hand from under her forearm to ward off A's right wrist, sinks her right hand and circles to the outside of A's right elbow, then turns her body to the left, wards off with her two hands backwards to the left to neutralize so that A loses his superior position and his head moves with the tuning of his trunk, looking to the left (the South)(Fig.177).

圖 177

164

圖 178

2、隨之，乙含胸收腹，上體回轉，雙手向下、向前推按甲的左前臂，轉入反攻。此時二人東西對視（圖178）。

b.Then, B contracts her chest and abdomen, rotates back her upper body, and pushes A's left forearm forwards and downwards with both hands, turn into a counterattack. At this time, both A and B are looking at each other (Fig. 178).

要點： 定勢時甲由弓步轉為虛步；乙由虛步轉為弓步。

Key points: When adopting the fixed postures, A shifts from a bow stance into an empty stance, and B shifts from an empty stance into a bow stance.

(九三) 甲掤手双按 (圖 179、180)
A-ward off and press two hands(179,180)

招法: 轉腰掤化，上步雙按。

Tactics: turn the waist to ward off, step up and press hands.

動作: 1、順乙按勢，甲左臂掤住乙雙手，重心後坐，上體左轉。右手掤接乙右腕，掌心向內；左手向下、向左繞至乙右肘外側。隨之上體回轉朝前，雙手掤化乙右臂向上繞至頭前（圖179）。

Movements: a.Follow B's pressing trend, A wards off B's hands with his left arm pinches, shifts bodyweight backwards, and turns his upper body to the left, blocks B's right wrist with his right hand, palm facing inwards; circles his left hand downwards to the left to the outside of B's right elbow, then turns his upper body back to the front, and blocks B's right arm upwards with both hands to the front of his head (Fig.179).

圖 179

2、上動不停。甲右腳前上一步（乙隨之左腳後腿一步），右手翻轉朝外，雙手牽引乙右臂向右、向下繞環，按至腹前。目視對（東）方（圖180）.

b.Without stopping, A takes a step forwards with his right foot (B then takes a step backwards with her left foot), rotates his right hand outwards, keeping the position of both hands unchanged, dragging B's right arm downwards to the right in a circle, and pressing to the front of the abdomen, looking at the opponent(the East)(Fig. 180).

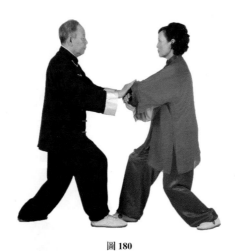

圖 180

要點：定勢時，甲由掤化轉為下按前推。二人成前四後六的虛步，兩腳全掌著地。

Key point: When adopting the fixed posture, A first wards off to neutralize, then presses downwards and pushes forwards. Both A and B form the empty stance,40% body weight on the front foot and 60% body weight on the back foot, with both soles of their feet on the ground completely.

(九四) 乙抱虎歸山 (圖 181、182)
B-embrace the tiger and return to the mountain

招法： 兩手分合，托手前送。

Tactics: separate and close the two hands, lift hands and extend arms.

動作： 1、乘甲上步向下向前推按之勢，乙左腳後退一步，重心後移（參見圖180）。隨之兩臂內旋，兩手翻轉朝外，向上、向兩側劃弧，分開甲的兩臂。目視前方（圖181）。

Movements: a. making use of A's forwards pushing the trend, B takes a step backwards with his left foot and shifts his bodyweight backwards (Fig. 180), then rotates both arms inwards, turns both hands outwards, draws in an arc upwards and to the sides to separate A's two arms, looking forwards(Fig.181).

圖 181

2、隨之，乙兩手向外繞至甲的兩前臂外側，兩臂外旋向內合併，兩手心朝上，托在甲兩前臂（或兩肘）下方。同時右腳收攏與左腳並步（甲相應左腳向前與右腳並步），蹬腿立身，雙手向前托送甲雙臂。二人注目，東西對視（圖182）。

b.Then, B circles her two hands to the outside of A's forearms and rotates her two arms inwards and closes them inwards, the palms facing upwards, and supporting under A's forearms (or elbows); at the same time, closes her right foot to stand with the left foot together(in response, A steps his left foot forwards to stand with his right foot together), presses her feet on the ground to make the body upright, with both hands lifting A's two arms pushes forwards. A and B are looking at each other, the East and the West(Fig. 182).

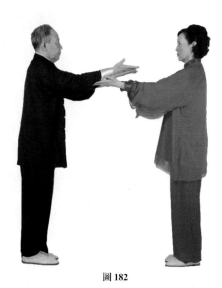

圖 182

要點： 兩手分合要與前臂內旋、外旋配合。托手送臂要與蹬腿立身、兩臂上舉配合。並手上托位置可托在甲前臂下方或肘關節下方。

Key point: The open and close of two hands should be harmonized with the rotations of forearms inwards and outwards. The lifting hands and extending arms should be harmonized with pressing legs and upright of the body as well as the extension of arms forwards. And the point of lift with the closing hands can be under A's forearm or his elbow joint.

（九五）甲、乙退步跨虎（圖183）
A、B-step backward and mount tiger(Fig.183)

動作： 兩人同時右腳後退一步，腳尖外展，重心後移，上體右轉，右腿屈坐。隨之將左腳微後收，腳前掌著地，上體歸正，成左虛步。同時兩手隨轉體交叉擺動劃弧，右手擺舉至頭前右上方，掌心斜向上；左手擺至左胯前，掌心向下。二人目光對視（圖183）。

圖 183

Movements： .Both of them take a step backwards with their right foot at the same time, swing the toes outwards, shift their bodyweight backwards, turn the upper body to the right, bend the right leg and sit, then retract the left foot slightly, resting on the forefoot on the ground, and return the upper body to the front respectively to form a left empty stance; at the same time, with the rotation of the body cross both hands and swing in an arc, the right hands are drawn to the upper right of the head, the palm tilting upwards, the left hands are moved to in front of the left hips, the palm facing downwards. Both A and B are looking at each other (Fig. 183).

要點： 兩手交叉擺動與重心移動和上體轉動協調一致，同時到位完成。定勢時上體中正，頂頭沈肩，含胸落胯，兩臂成弧形。

Key point: The crossing and swing of the two hands should be harmonized with the shifting body weight and rotation of the upper body and finish in place at the same time. While adopting the fixed posture, the upper body is upright and centered, lift the top, sink shoulders, contract chest, and lower hips, and bend the two arms slightly to form an arc.

(九六) 甲、乙轉身擺蓮腳 (圖 184、185、186、187)
A、B-turn body and swing (Lotus) kick (Fig.184-187)

動作: 1、二人以左腳掌和右腳跟為軸，向右後方碾腳轉體半周+45度。甲向西北上步成左弓步；乙向東南上步成左弓步。同時左臂外旋，左手掌心朝上，經腰間和右手上方向前上穿伸至頭前；右手掌心向下，屈收至左肘下方。目視左掌（圖184、185）。

Movements: a.A and B use the left sole and right heel as the axis, grinding on the ground and rotating their bodys 225° backwards to the right, A steps up in direction of the Northwest to form a left bow stance, B steps up in direction of the Southeast to form a left bow stance; at the same time, rotate their left arm outwards, the left palms facing upwards, and stretch out from the waits and the upper part of the right hands forwards to in front of the head; the right palms face downwards and close under the left elbows, looking at the left palms (Fig. 184 and 185).

圖 184

圖 185

2、重心右移，左腳內扣，身體右轉，重心再移向左腿，提起右腳跟。兩手隨轉體向上向右劃弧擺至身體右側，掌心斜向下。右掌高與肩平；左掌高與胸齊。頭轉視右掌（圖186）.

b.Shift the body weight to the right, buckle the left foot inwards, turn the body to the right, then shift the bodyweight again to the left leg, and lift the right heel, swing both hands in an arc upwards to the right side of the body with rotation of the body, palms tilting downwards. The right palms are at shoulder height, the left palms are high at the chest level, turn their heads to look at the right palms (Fig. 186).

圖 186

3、上體左轉，右腿自然伸直，自右向左、向上、向右成扇形踢擺。右腳經過頭前時，腳面繃平，雙手自右向左依次迎拍右腳面。目視雙手（圖187）。

c. Turn the upper body to the left, straighten the right legs naturally, and kick in a fan shape from right to left, upwards and to the right. The instep of the right foot is stretched flat, and while passing in front of the heads, slap on the surface of the right insteps with both hands from right to left in the sequence, looking at both hands (Fig. 187).

圖 187

要點：擺蓮拍腳是太極拳重要腿法。擺腿速度可快可慢，不可忽快忽慢。擺踢時髖關節要鬆活。向左、向上踢擺時要收腹合胯。擊拍腳面要準確響亮。擊拍後要展腹開胯。

Key points: The lotus kick and slapping the feet is an important legwork of Taijiquan. The speed of the swing leg can be fast or slow but should be even. You should lose your hip joints while swinging and should pull in your abdomen and close your hips while kicking upwards to the left. The slapping foot should be accurate and loudly. After the slap, relax the abdomen and open the hips.

(九七) 甲、乙右彎弓射虎 (圖 188)
A、B-curved bow to shoot tiger-righ(Fig.188)

動作： 二人向右轉體。甲向南落步，乙向北落步，二人屈膝前弓成右弓步。同時兩手自左側下落握拳。隨上體右轉，右拳經腹前向右、向上劃弧擺至頭右側上方，前臂內旋，拳眼斜向下；左拳經右胸前向對方沖打，拳眼向上，高與肩平。目視對方（圖188）。

圖 188

Movements: The two turn to the right. A steps up to the South, B steps up to the North, and they bend their knees forwards to form right bow stance; at the same time, drop both hands from the left sides and clench the fists, then turn the upper bodies to the right, and swing the right fists in an arc through from in front of the abdomens forwards to the right and upwards to the upper right side of the head, rotate the forearms inwards, the heart of the fists tilting downwards, punch the left fist to in front of their opponents' chests, the heart of the fists facing upwards at shoulder level, looking at each other (Fig. 188).

要點： 定勢時，二人皆為右弓步架沖拳。甲弓步向南；乙弓步向北。甲沖拳與目視方向東偏北；乙沖拳與目視方向西偏南。

Key point: While adopting the fixed postures, both of them block high and punch the fists in the right bow stances. A's bow stance faces to the South and B's bow stance faces to the North. A punches his fist and looks in the direction of the Northeast and B punches her fist and looks in the direction of the Southwest.

（九八）甲、乙左彎弓射虎 （圖189）

A、B-curved bow to shoot tiger-left(Fig.189)

動作： 二人重心後移，身體向後轉，右腳尖內扣；左腳尖外展，屈膝前弓成左弓步。同時左拳向下落經腰間，內旋向左、向上劃弧，停於頭左側上方，拳眼斜向下；右拳下落經胸前向對方沖打，拳眼向上，高與肩平。目視對方（圖189）。

圖 189

Movements: The two of them shift their bodyweight backwards, turn their bodies backwards, and buckle their right toes inwards, swing their left toes outwards, bend their knees forwards to form a left bow stance; at the same time, move the left fists downwards through the waist and draws in an arc to the left and upwards, and stop at the upper left side of the heads, rotate the forearms inwards, the heart of the fists tilting downwards, drop the right fists through the chests to punch to the opponents' chests, the heart of the fists facing upwards at shoulder level, looking at each other(Fig. 189).

要點： 定勢時，二人皆為左弓步架沖拳。甲弓步向北；乙弓步向南。甲沖拳與目視方向東偏南；乙沖拳與目視方向西偏北。

Key points:While adopting the fixed postures, both of them punch the fists in the left bow stances. A's bow stance faces to the North and B's bow stance faces to the South. A punches his fist and looks in the direction of the Northeast and B punches her fist and looks in the direction of the Southwest.

（九九）甲、乙進步搬攔捶（圖 190、191、192）

A、B-steps forwards deflect, parry and punch(Fig.190-192)

動作： 1、二人收提右腳至左腳內側。同時左拳變掌落至胸前，掌心朝下；右拳屈收至左肋前，拳心朝下。隨之上體右轉，右腳向前擺腳上步。甲向東上步；乙向西上步。同時右拳經左前臂內側向上、向體前翻壓，拳心向上，力在拳背；左掌下按至左髖旁。目視右拳（圖190）。

Movements:a.The two of them lift their right foot to the inner side of the left feet, at the same time, unclench the left fists and drop to in front of the right chests, the palms facing downwards, move the right fists to the lower part of the inner side of the left forearm, the heart of the fists facing downwards, then turn the upper bodies to the right, and swing the right feet and step forwards. A steps up eastwards and B steps up westwards; at the same time, pass the right fists through the inner side of the left forearms and flip and press upwards to in front of the body, the heart of the fists facing upwards, the point of force concentrating on the back of the fists, press the left palms downwards to the side of the left hips, looking at their right fists (Fig. 190).

圖 190

2、上勢不停，上體右轉，左腳向前上步，腳跟著地成左虛步。同時左掌向左向上向前劃弧，擺至體前成側立掌，掌心向右，與肩同高；右拳內旋向右劃弧，再外旋收至腰間，拳心向上。目視對方（圖191）。

b.Without stopping, turn the upper bodies to the right, step the left feet forwards, resting on the heels on the ground to form empty stances, at the same time, draw the left palms an arc the left and upwards and forwards and swing to the front of the body to form a side standing palm, the palm facing to the right at shoulder height, rotate the right fists inwards and draw in an arc to the right, then outwards to the waists, the heart of the fists facing upwards, looking at each other (Fig. 191).

圖 191

3、隨之，二人重心前移成左弓步。右拳從腰間內旋向前沖打，拳眼朝上，高與肩平；左掌後收附在右前臂內側，掌心向右，指尖斜朝上。目視右拳（192）。

c.Then, the two of them shift their bodyweight forwards to form left bow stances, rotate the right fists inwards from the waist and punch forwards, the eye of the fists facing upwards at the shoulder height, withdraw the left palms backwards, and attach to the inside of the right forearms, the fingertips facing upwards, looking at their right fists(192).

圖 192

　　要點： 搬和攔是太極拳的招法術語。搬的原意是搬開，攔的原意是阻攔。用在太極拳招法上，搬是向外格擋，攔是向內格擋，二者都是阻截對方進攻的防守招法。進步是太極拳常用步法。一腳向前上一步，腳尖外擺，隨之另一腳再向前上一步。第一步擺腳上步為第二步做好舖墊，連上兩步稱為進步。

Key point: Ban and Lan are the technical terms of Taijiquan. The original meaning of Ban is to move away, and the original meaning of Lan is to block. In terms of Taijiquan techniques, Lan is to block outwards, and Lan is to block inwards. Both are defensive techniques to block the opponent's attack. JinBu is common footwork in Taijiquan. Step one foot forwards with swinging toes outwards, followed by another foot to step forwards. The first step with swinging toes paves the way for the second step, and to move two steps forwards continuously is called JinBu.

（一 00） 甲、乙如封似閉 （圖 193、194）
A、B-Apparent close up(Fig.193,194)

動作: 1、左掌外旋，掌心向上，從右前臂下方穿出；右掌同時外旋向上，兩腕關節交搭，右手在上。隨之重心後移，左腳尖翹起。兩掌邊收邊分邊內旋收至胸前，掌心斜向前下方，與頭同寬。目視前方（圖193）。

Movements: a.They rotate the left palms outwards, the palms facing upwards, and stretch out from under the right forearms, at the same time, rotate the right palm outwards and upwards, cross the two wrist joints together, with the right hand on top; then shift the bodyweight backwards, toes up, withdraw two palms to in front of the chest while separating the palms, rotate two arms inwards, the palms tilting inwards and downwards, at head width, looking forwards (Fig.193).

圖 193

2、隨之，重心前移，左腿屈弓成左弓步。同時兩掌並行向前推出，掌心朝前，指尖向上，與肩同高同寬。目視前方（圖194）。

b.Then, shift the bodyweight forwards, and bend the left legs into left bow stances; at the same time, push both palms parallel forwards, the palms facing forwards, fingertips facing upwards, at shoulder height and shoulder width, looking forwards (Fig.194).

圖 194

要點： 此時甲乙二人交錯相對，目視自己前方，不是注視對手。

Key point: At this moment, A and B stagger each other, looking forwards respectively instead of looking at each other.

（一０一）甲、乙十字手（圖 195、196）
A、B -Cross Hands(Fig.195,196)

動作： 1、二人重心右移，上體右轉，左腳尖內扣，右腳尖外展。同時右手隨轉體向右分開，經面前劃弧擺至身體右側，與左手成左右平舉。頭隨體轉，隨視右手（圖195）。

Movements: a.They shift their body weight to the right and turn the upper body to the right, buckle the left toes inwards, and the right toe is abducted; at the same time, separate the right hands to the right with the rotation of the body, and while passing in front of the faces, draw in an arc to the right side of the body to hold horizontally together with the left hand, heads move with the rotation of their trunks, looking at their right hand (Fig.195).

2、上勢不停，重心左移，上體左轉，右腳尖內扣，右腳收至左腳旁，兩腳平行，腳尖朝南，與肩同寬，兩腿緩緩直立。同時兩手下落，向內劃弧。於腹前交叉，兩臂環抱舉至體前，與肩同高。右手在外，兩手心朝內。目平視前方（圖196）。

b.Without stopping, shift the bodyweight to the left, turn the upper body to the left, buckle the right toes inwards, and close the right foot to the side of the left foot. The feet are parallel, the toes facing the South, at shoulder-width apart, and strengthen the legs slowly upright; at the same time, drop both hands and draw in an arc inwards, and cross together in front of the abdomen, then raise the two arms to in front of the body, at shoulder-height, with the right hands at outside, the palms facing inwards, looking straight forwards(Fig.196).

圖 195 　　　　　　　圖 196

要點：重心右移，兩臂分展時，動作要連貫均勻，不可斷勁。兩臂不可伸直，要自然微屈，沈肩、墜肘、塌腕、含胸。兩臂張開小於180度。兩臂環抱兩手交叉時，要有掤勁，內氣充盈如同抱球。不可鬆軟，也不可抱緊。

Key points: While shifting the bodyweight to the right and separating the arms, the movements should be smooth and even, without breaking the strength, and the arms must not be straight. You should bend the arms naturally, sink shoulders, lower elbows, and arcing wrists. While embracing the two arms and crossing the two hands, it should have ward-off force, and be full of inner energy as if holding a ball, neither being too soft nor holding too tight.

(一〇二) 甲、乙收勢還原 (圖 197、198、199、200)
A、B-closing form, return to original stance(Fig.197-200)

動作: 1、兩手內旋分開，與肩同寬，掌心斜向前下方。隨之，兩臂緩緩下落，兩手垂於大腿外側，掌心朝內。目視前方，甲面向南，乙面向北（圖197、198）。

Movements: a. They rotate both hands inwards and separate shoulder-width apart, the palms tilting forwards and downwards, then, drop their two arms slowly to outside of the thighs, looking forwards, A facing to the South and B facing to the North (Fig.197 and 198).

圖 197

圖 198

2、二人同時左腳向右腳並步。稍停，向左轉身移步，成東西相對，互致抱拳禮。禮畢垂手還原成預備勢（圖199、120）。

b.At the same time, both of them close their left feet to the right. Stop for a while, turn to the left and move the steps, the direction of east and west, facing each other, holding fists together to salute each other, then drop their hand to the original ready positions (Fig.199 and 120).

圖 199 　　　　　　　　　　　　　　　　圖 200

　　要點： 自始至終精神集中，情緒飽滿，合作禮讓，尊重對手。收勢後互致抱拳禮。身型保持中正安舒，頂頭沈肩，含胸展臂，呼吸自然。

Key points: It is required from the beginning to the end, concentrated spirit, full of emotions, cooperation, and courtesy, respect for opponents. After closing position, they exchange the fist salutes, The shape is to be straightened, balanced, stable and quiet, lift top and lower shoulders, contract the chests and extend the arms, breathing naturally.

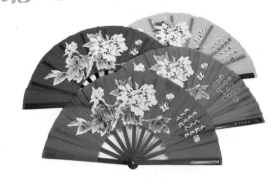

【太極扇】

武術/廣場舞/表演扇

可訂制LOGO

紅色牡丹

粉色牡丹

黃色牡丹

紫色牡丹

黑色牡丹

藍色牡丹

綠色牡丹

黑色龍鳳

紅色武字

黑色武字

紅色龍鳳

金色龍鳳

純紅色

紅色冷字

紅色功夫扇

紅色太極

打開淘寶天貓APP

掃碼進店

微信掃一掃

進入小程序購買

【專業太極刀劍】

晨練/武術/表演/太極劍

打開淘寶天貓
掃碼進店

| 手工純銅太極劍 | 神武合金太極劍 | 桃木太極劍 | 平板護手太極劍 | 手工銅錢太極劍 | 鏤空太極劍 |

手工純銅太極劍　神武合金太極劍

劍袋·多種顏色、尺寸選擇

銀色八卦圖伸縮劍　　銀色花環圖伸縮劍

龍泉寶刀

棕色八卦圖伸縮劍　紅棕色八卦圖伸縮劍

微信掃一掃
進入小程序購買

【太極羊・專業武術鞋】

兒童款・超纖皮

打開淘寶APP
掃碼進店

XF808-1 銀

XF808-1 白

XF808-1 紅

XF808-1 金

XF808-1 藍

XF808-1 黑

XF808-1 粉

微信掃一掃

進入小程序購買

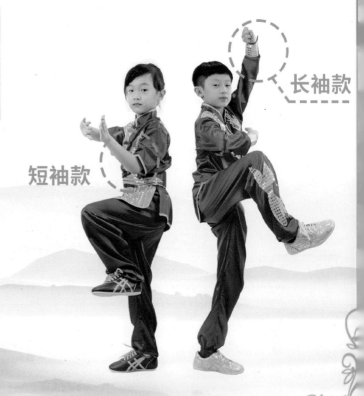

长袖款

短袖款

【武術/表演/比賽/專業太極鞋】

正紅色【升級款】
XF001 正紅

打開淘寶天貓
掃碼進店

微信掃一掃
進入小程序購買

藍色【經典款】
XF8008-2 藍

黃色【經典款】
XF8008-2 黃色

紫色【經典款】
XF8008-2 紫色

正紅色【經典款】
XF8008-2 正紅

黑色【經典款】
XF8008-2 黑

綠色【經典款】
XF8008-2 綠

桔紅色【經典款】
XF8008-2 桔紅

粉色【經典款】
XF8008-2 粉

XF2008B（太極圖）白

XF2008B（太極圖）黑

XF2008-2 白

XF2008-3 黑

5634 白

XF2008-2 黑

【專業太極服】
多種款式選擇・男女同款

微信掃一掃
進入小程序購買

黑白漸變仿綢

淺棕色牛奶絲

白色星光麻

亞麻淺粉中袖

白色星光麻

真絲綢藍白漸變

香港國際武術總會裁判員、教練員培訓班
常年舉辦培訓

　　香港國際武術總會培訓中心是經過香港政府注册、香港國際武術總會認證的培訓部門。爲傳承中華傳統文化、促進武術運動的開展，加强裁判員、教練員隊伍建設，提高武術裁判員、教練員綜合水平，以進一步規範科學訓練爲目的，選拔、培養更多的作風硬、業務精、技術好的裁判員、教練員團隊。特開展常年培訓，報名人數每達到一定數量，即舉辦培訓班。

報名條件：熱愛武術運動，思想作風正派，敬業精神强，有較高的職業道德，男女不限。

培訓內容：1.規則培訓；2.裁判法；3.技術培訓。考核內容：1.理論、規則考試；2.技術考核；3.實際操作和實踐(安排實際比賽實習)。經考核合格者頒發結業證書。培訓考核優秀者，將會錄入香港國際武術總會人才庫，有機會代表參加重大武術比賽，并提供宣傳、推廣平臺。

聯系方式

深圳：13143449091(微信同號)

　　　　13352912626(微信同號)

香港：0085298500233(微信同號)

國際武術教練證　　　國際武術裁判證

微信掃一掃

進入小程序

香港國際武術總會第三期裁判、教練培訓班

打開淘寶APP

掃碼進店

【出版各種書籍】

申請書號>設計排版>印刷出品
>市場推廣
港澳台各大書店銷售

冷先鋒

國際武術大講堂系列教程之一
《太極拳對練》

總 編 輯：冷先鋒

責任印製：冷修寧

翻　譯：Xiaoqiong Wang(王小瓊)

版面設計：明栩成

香港先鋒國際集團　審定

太極羊集團　　贊助

香港國際武術總會有限公司　出版

香港聯合書刊物流有限公司　發行

代理商：臺灣白象文化事業有限公司

國際書號：978-988-75078-1-9

香港地址：香港九龍彌敦道 525 -543 號寶寧大廈 C 座 412 室

電話：00852-98500233 \91267932

深圳地址：深圳市羅湖區紅嶺中路 2118 號建設集團大廈 B 座 20A

電話：0755-25950376\13352912626

臺灣地址：401 臺中市東區和平街 228 巷 44 號

電話：04-22208589

印次：2021 年 6 月第一次印刷

印數：5000 冊

網站：www.hkiwa.com　　Email: hkiwa2021@gmail.com

海外網网址：www.deyin-taiji.com / www.taichilink.net

Tel: 0044 7779 582940